RON RANSON ON SKIES

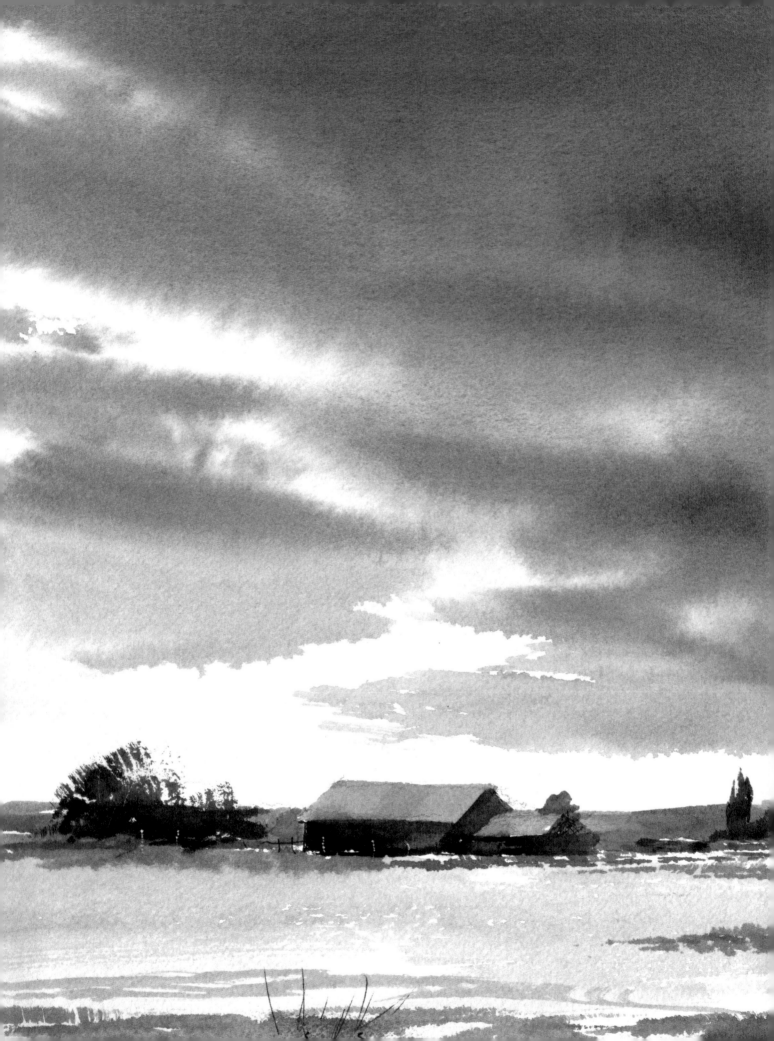

RON RANSON

ON SKIES

Techniques in watercolour
and other media

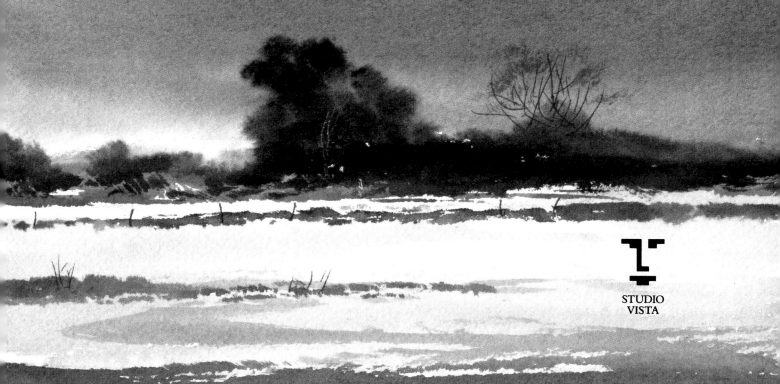

STUDIO
VISTA

ACKNOWLEDGEMENTS

In writing a book of this type, I've relied on the skills of others, particularly for the more technical details. Mrs Frankie Pullinger from the Meteorological Office has been extremely helpful in supplying technical material and also put me in touch with Mr C. S. Broomfield, Mr S. D. Burt, Mr F. Norton and Mr R. K. Pilsbury, to whom I'm most grateful for allowing me to use their transparencies. However, the majority of the photographs were taken by my good friend Ray Mitchell in the UK and by Doug Fontaine, a young American photographer from Oregon.

I was delighted to be allowed to use the work of artist friends Barry Watkin, Trevor Chamberlain and Ian Houston.

My thanks must go too to Ann Mills, who has, as always, helped me enormously with the writing and layout of the book. My dear wife, Darlis, has done all the typing and has encouraged and supported me throughout.

STUDIO VISTA an imprint of Cassell

Wellington House, 125 Strand, London WC2R 0BB

Copyright © Ron Ranson 1996

First published 1996

British Library Cataloguing in Publication Data
A catalogue record for this book is available from the British Library

ISBN 0 289 80152 4

Distributed in the United States
by Sterling Publishing Co., Inc.
387 Park Avenue South, New York, New York 10016-8810

Typeset by AccComputing, Castle Cary, Somerset
Printed and bound in Spain
by Bookprint S.L., Barcelona

About the Author and This Book

Capricorns are notoriously late developers and Ron Ranson is a typical example, having changed his direction in life from engineering to painting at the age of fifty. Now with more than twenty books, several videos and countless magazine articles to his credit, he has retained all the enthusiasm and joy for his art which he has felt since he became a full-time painter some twenty years ago. This, along with his expertise as an artist, teacher, writer and broadcaster, has earned him a huge following worldwide. His travels have brought him into contact with both professional artists and students, in places as diverse as Norway and Borneo. Perhaps this diversity of experience has helped Ron's open-minded and fresh approach to painting, which appeals to art lovers, students and other professionals alike.

Whether travelling in Europe and further abroad in such countries as America, Australia, New Zealand, Oman and South Africa or whether he is at home in the beautiful countryside of the Forest of Dean and south Gloucestershire, Ron is always seeking to broaden his artistic horizons. At the same time he is looking to spread the word about the excitement of painting with a clarity and directness which has brought a breath of fresh air into the world of art.

This book is a must for everyone, whether student or professional painter, who wants to paint landscape. It covers all aspects of painting skies, as well as giving clear explanations for some of the marvellous effects which we see daily above our heads. It will be a constant companion for all those who are keen to improve their outdoor painting. Once you have read this volume, the author is convinced that you will never look at the sky in quite the same way again and that your paintings will be enhanced in style and content.

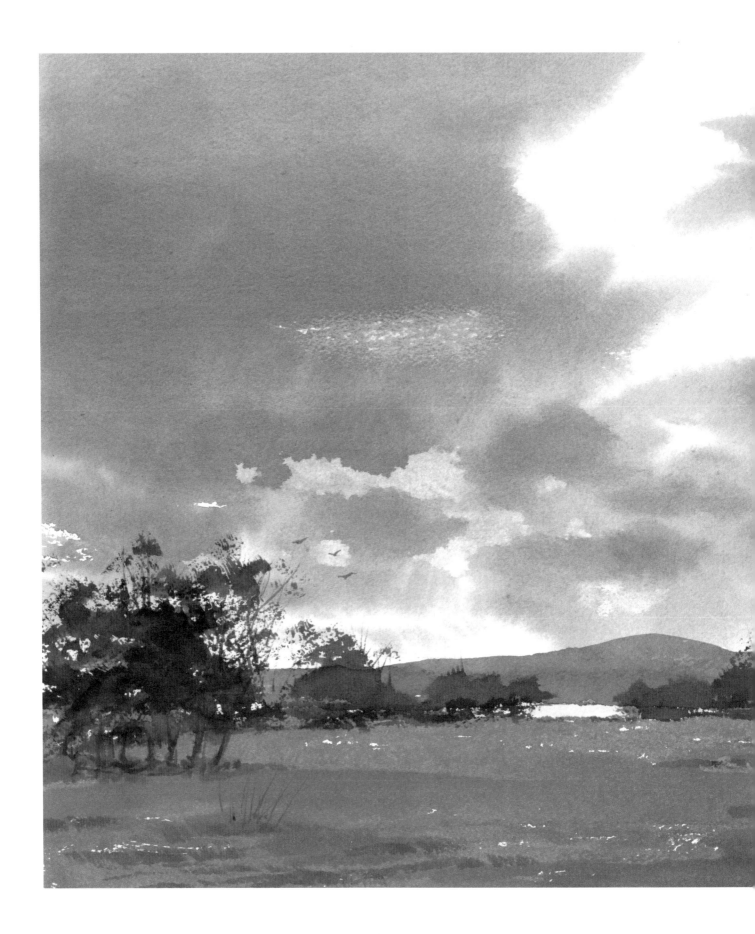

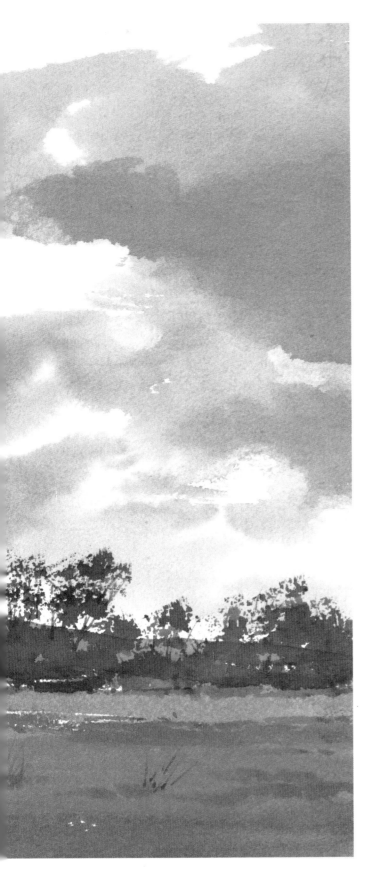

Contents

Introduction

You may be asking yourself why I'm attempting a book exclusively about skies. You may even think that this is getting too specialized. However, having written several general books on watercolour, I've come back time and time again to the realization that skies dictate the whole mood and feeling of a painting. Yet this aspect of painting remains one of the most neglected and while much time and concentration are spent on things such as trees, buildings and rivers, the sky often remains merely an afterthought.

Let's take a moment or two to imagine a quiet estuary drenched in sunshine which blazes down from a clear blue sky – just feel the warmth! Now transform the scene. Perhaps there's a storm approaching, and the warm blue gives way to dark, cool grey, which is matched by the water below. Although all the component parts of the scene are exactly the same, the whole atmosphere has changed and the mood is completely different.

Why, then, when it is obviously so important, is the sky treated in such a cavalier fashion? It seems to me that one of the main reasons is fear, caused by a lack of knowledge. As a teacher, I am often amazed how little basic knowledge students have about the sky above them. Even such fundamentals as the fact that white cumulus clouds are like pieces of cotton wool under a spotlight, with a shadow beneath them, have to be explained.

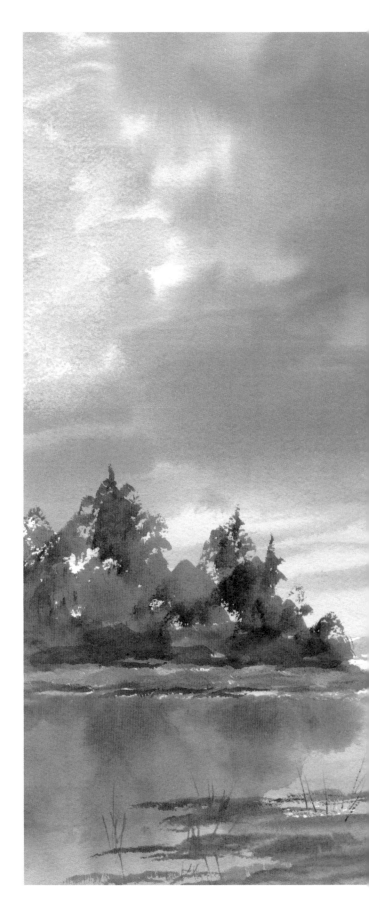

The feeling of peace and space in this composition is enhanced by the mixture of warm and cool colours throughout the painting. A sense of unity is provided by the reflection in the water of the warm patch of sky above, and by the grey of the clouds being repeated in the trees on the distant horizon. The eye is directed, by the main sweep of clouds, to the dark group of trees and their reflection on the left. The greatest warmth has been reserved for the foreground shore, giving perspective and depth to the scene.

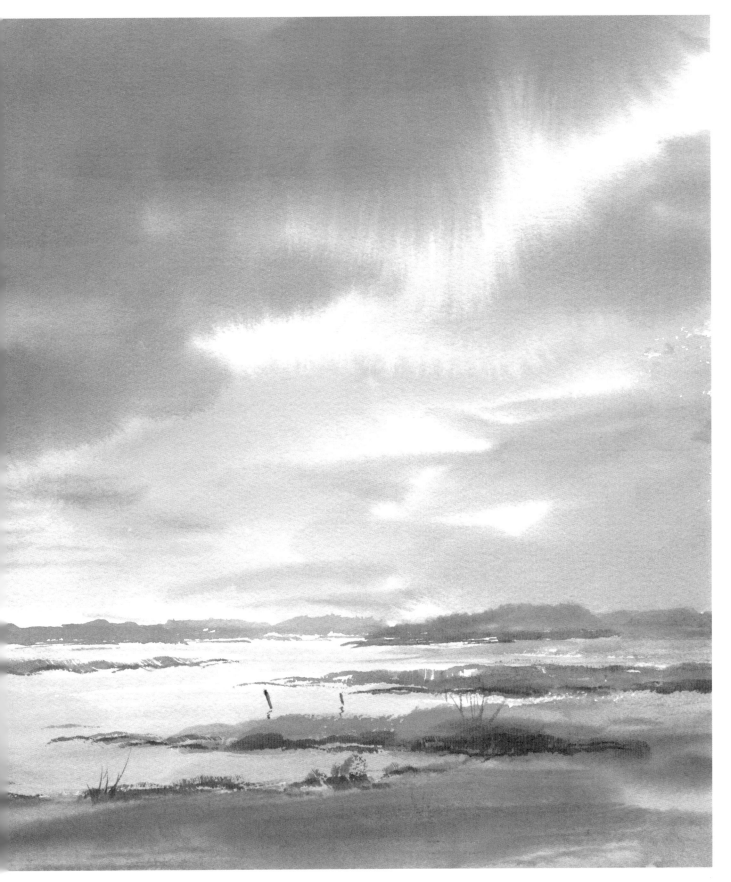

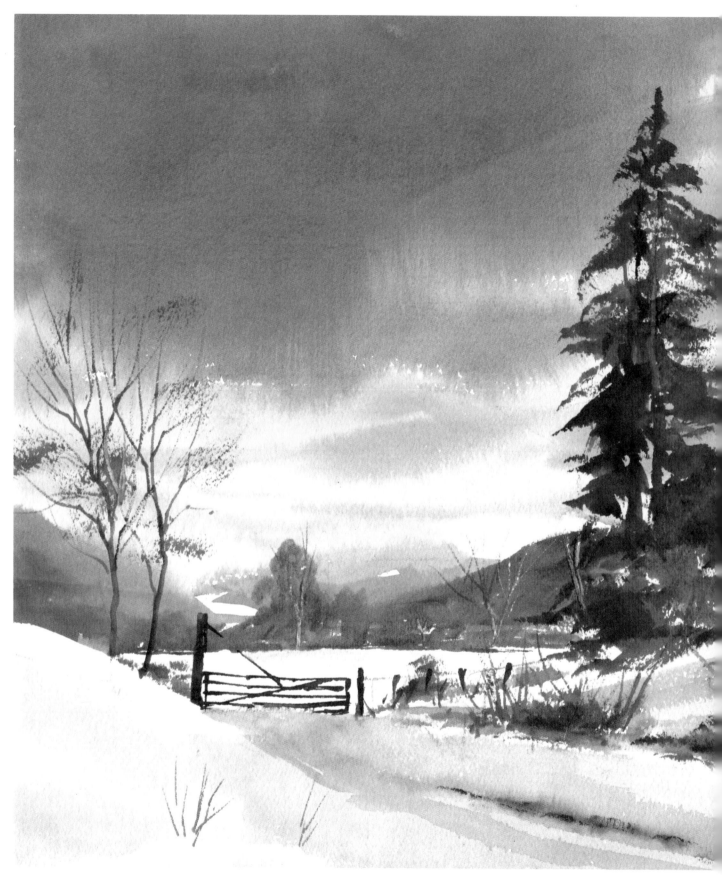

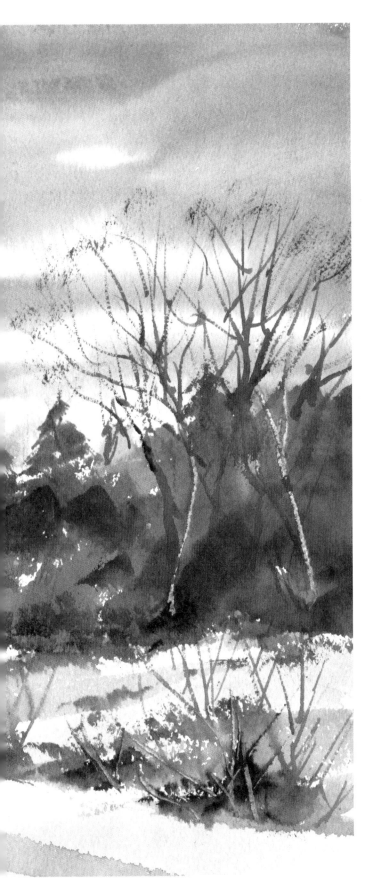

Also, that these clouds are large in the foreground and become smaller as they recede towards the horizon. One would think that people never raise their eyes heavenwards or glance out of a window! This leads me to another important point. Always remember that what we see as we look up or out does not have to be faithfully reproduced in every detail. Hopefully, what we see will act as a catalyst to inspire our own creativity as we attempt to capture the mood and feelings brought about by a particular sky.

In the course of the book I've tried to cover every aspect of painting skies (although I'm sure you will always find others to tantalize and excite you). We'll look at some of the problem areas, such as how to make clouds look light and fluffy, or menacing and heavy, and how to gradate a clear blue sky, giving it interest and expression.

I hope that you will become as enthralled by the subject of skies as I am. I truly believe that the sky, in any of its guises, provides one of the richest and most rewarding subjects, as well as the most inspirational. My first idea for a title for this book was *Reach for a Sky*, and this is what I want you to do whenever you feel in need of a little inspiration. The material isn't meant to be copied – in fact, that's impossible. Because of the speed at which you have to work, no two skies are ever going to be the same – that's all part of the excitement. But the examples will hopefully boost your confidence and help your design. Successful skies are a combination of acquired skill, some courage and a little luck. It's surprising, though, how much your luck increases as your skills improve.

The sky colour here dominates, as it influences all other colours throughout the scene, especially the surface of the snow. The main object of interest is the gate. Not only is it the sole man-made object in the scene, but also the eye is directed towards it by the track, and by having the brightest colour behind it. The vertical trees serve several purposes: they lock sky and landscape together; the calligraphy emphasizes the softness of the sky; and the fir tree adds a rich quality to the scene.

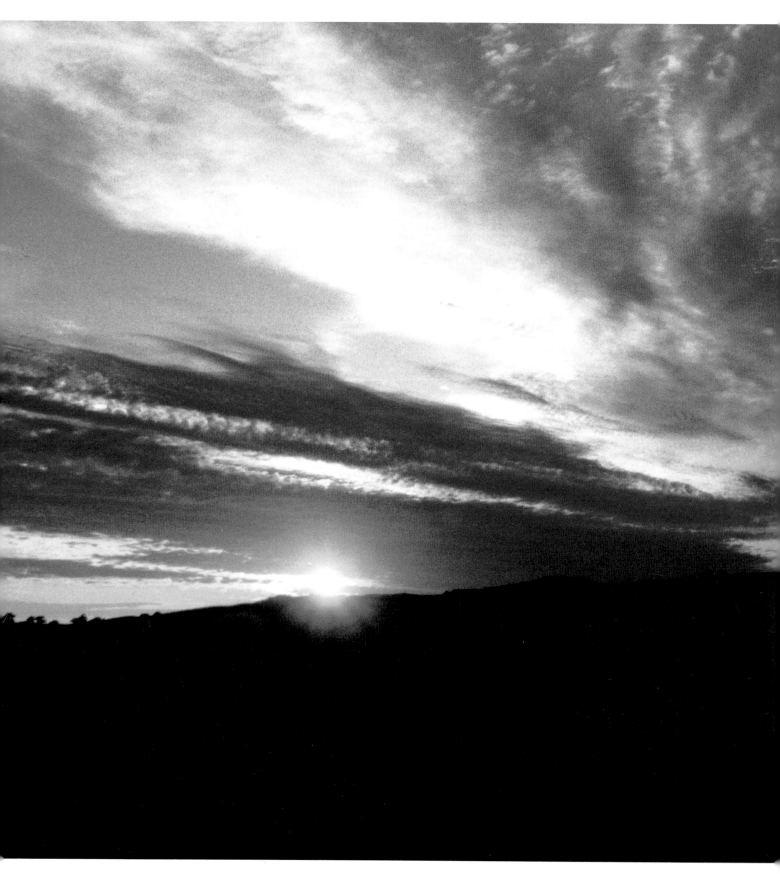

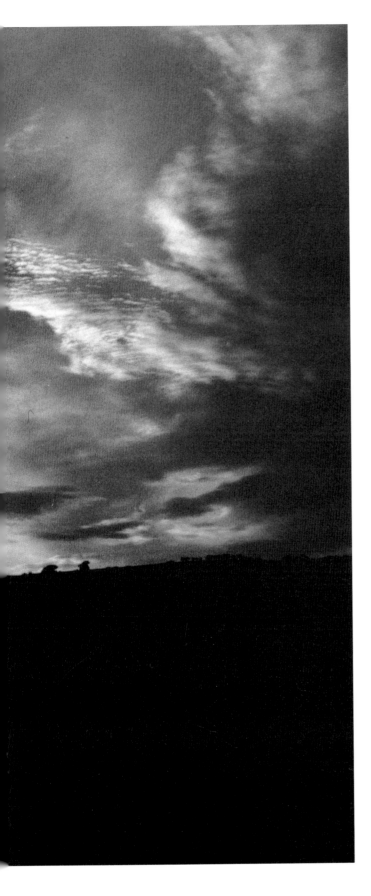

Understanding Skies

If you're really serious about depicting convincing skies, then you'll bear with me while I explain how skyscapes are formed. Without wishing to sound negative, I have to say that many painters seem to put on various colours in a random rather than a constructive way, hoping that the result will somehow be convincing. It usually isn't! It's rather like an author attempting a novel without having researched his subject: the gaps in his knowledge will quickly become obvious to all.

Basically, it's absolutely essential to know at least the various cloud formations and how they come into being. At the risk of stating the obvious, clouds are formed as a result of the exchange of moisture between the earth and its atmosphere, the rise and fall of barometric pressure, together with temperature changes, and the winds, which vary in speed and altitude as they move the air across the land. Clouds appear, disappear and take their different shapes as these conditions vary. The powers that be have classified cloud forms into ten major types, divided into three groups according to their altitude. The names are based on four simple Latin words:

CIRRUS Fringe or thread

CUMULUS Heap

STRATUS Layer

NIMBUS Rain

Don't let any of this frighten you, but rather take heart. As an artist, what you are trying to do is to capture the atmosphere created by the

This exciting evening sky by Doug Fontaine is the sort that takes your breath away and lasts only a few minutes. There is a strong feeling of movement in this inspirational photograph.

wonderful shapes, which alter constantly as you watch. You may say, as many of my students do, 'It's impossible – it's all happening too fast.' But, like a fast-moving stream, the overall pattern is repeated again and again. You could find your early attempts a little depressing; they may be timid and lacking in conviction. Don't be put off, though. Persevere and your confidence will increase with practice. Remember, the illusion you're trying to create is of a vast dome of space against which clouds are constantly moving. Once you're over that initial fear, you will begin to really enjoy the excitement. Myself, I get more fun out of painting skies than anything else.

In the next few pages I'll be showing you photographs of the various cloud types which will, I hope, make the whole business more under-standable and interesting.

Cirrus

These are the highest cloud types, forming at about 6,000–12,000 metres (20,000–40,000 feet). Made up of ice crystals, they create a wonderful variety of delicate textures, some of which you will know and recognize as 'mare's tails'. They can appear at any angle and so offer far more in a compositional sense than any other cloud formation. Within the cirrus family there are two other formations, cirrocumulus and cirrostratus, both of which are illustrated here.

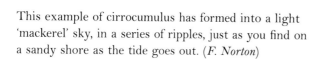
This example of cirrocumulus has formed into a light 'mackerel' sky, in a series of ripples, just as you find on a sandy shore as the tide goes out. (*F. Norton*)

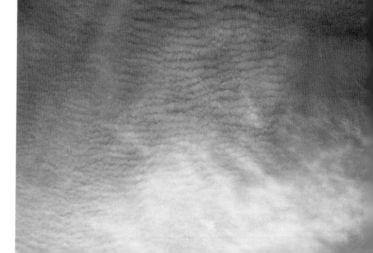

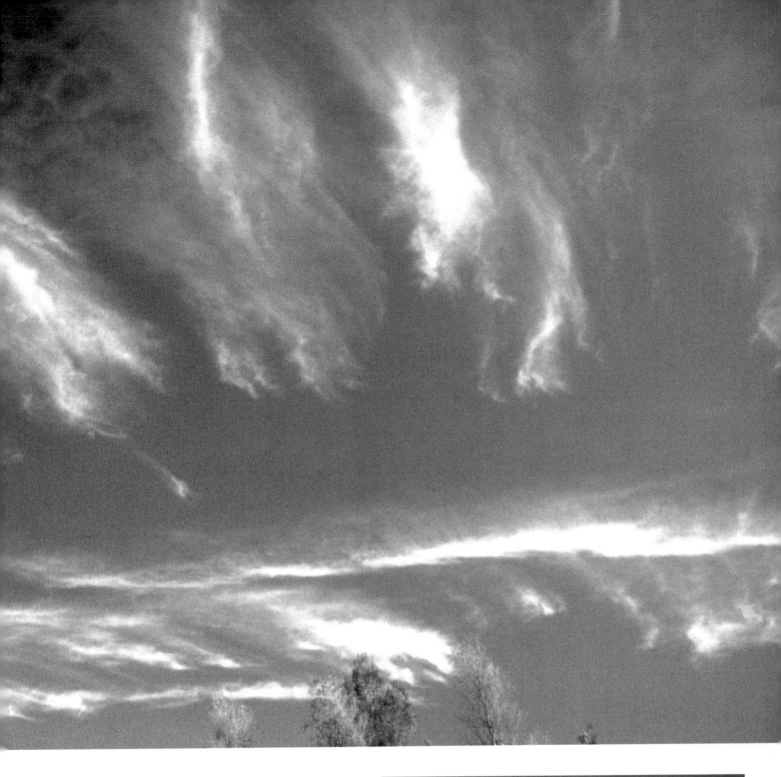

This is an example of the sort of cirrus we most readily recognize. The 'mare's tails' are formed by strands trailing from a small hook or tuft. These clouds can probably be seen at their most beautiful as they catch the rays of a setting sun. (*R. K. Pilsbury*)

Here we see cirrostratus throwing a thin veil over the entire sky, through which the sun can still be seen, the cloud forming a halo effect around it. (*R. K. Pilsbury*)

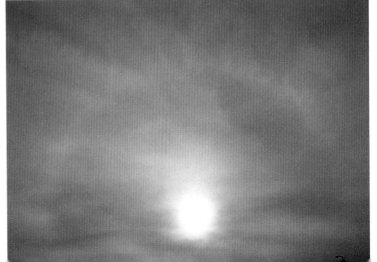

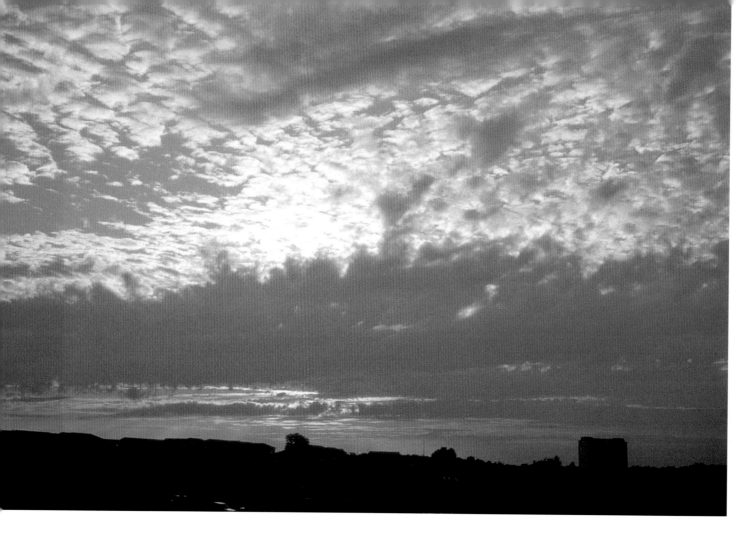

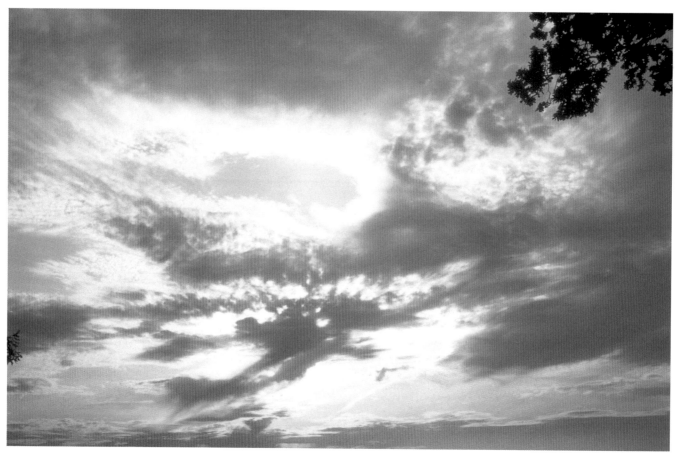

Cumulus

The highest clouds with cumulus in their manes are known as altocumulus and altostratus. These form at about 2,000–3,500 metres (7,000–20,000 feet). The altocumulus can create very beautiful cloud shapes, while the altostratus are simply level layers of featureless grey.

The lowest cloud formations contain strato-cumulus, stratus, nimbostratus, cumulus and cumulonimbus, all of which are formed up to 2,000 metres (7,000 feet).

This photograph (opposite, above) was taken when the sun was low in the sky and the difference in colouring shows two quite distinct layers. (*C. S. Broomfield*)

Here we see (opposite, below) the altocumulus of a chaotic sky in several layers. The lowest appears grey in the light of the setting sun. (*C. S. Broomfield*)

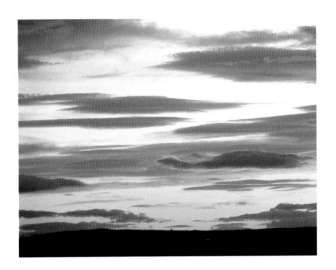

This lovely Aberdeen sunset shows up the altocumulus in its lenticular form. You'll see it featured in many of the illustrations throughout this book. (*R. K. Pilsbury*)

The clouds here are reflecting the colours of the evening sun. Because of the height of the sun, the clouds are lit from below, and the shadows, unlike in a daylight sky, are at the tops of the clouds. (*C. S. Broomfield*)

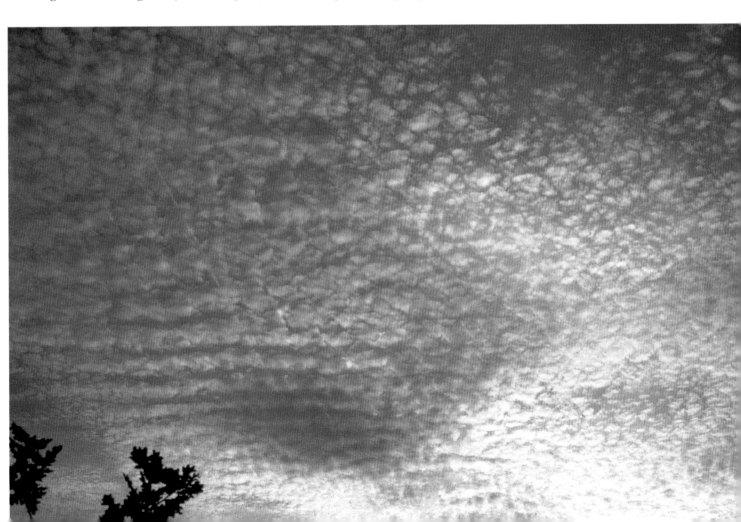

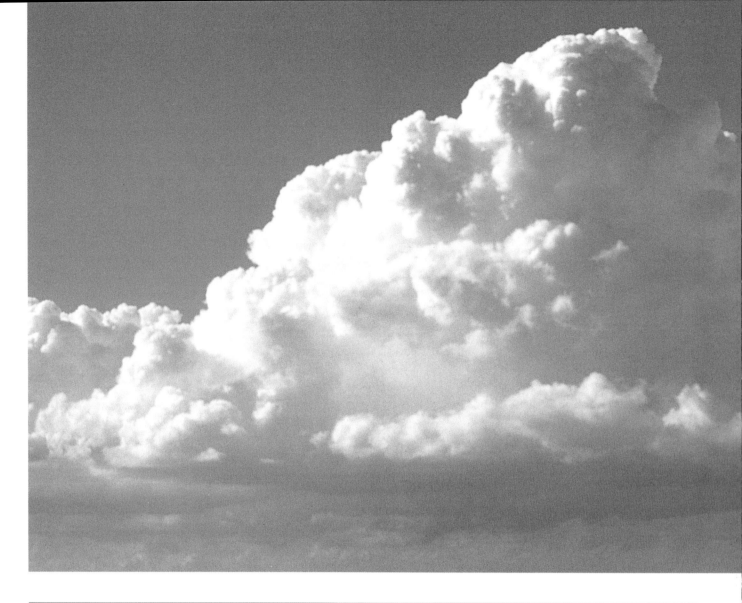

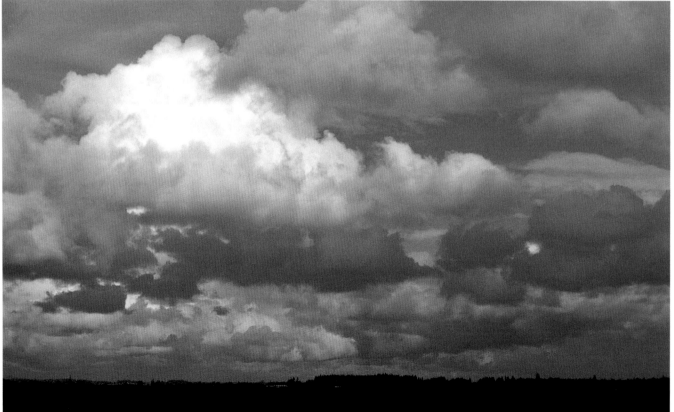

On these pages I've concentrated, along with altocumulus, on cumulus and cumulonimbus as the most interesting artistically speaking. Cumulus are fluffy and white, cauliflower-shaped on top, with a flatter base which will always appear parallel to the horizon. Cumulonimbus will often provide a strong compositional aid, as the tops of the masses of vertical clouds spread out to form strong anvil shapes.

This is a classic example of a cauliflower-shaped cumulus cloud, which can completely dominate a sky in a very dramatic way. Sunlit parts are mostly brilliant white, while bases are relatively dark – a positive gift to a painter! (*R. K. Pilsbury*)

Here we see (opposite, below) a mixture of stratocumulus and cumulus clouds. The stratocumulus are at about 1,000 metres (3,500 feet), while the cumulus are at 600 metres (2,000 feet), forming an interesting mix. (*D. Fontaine*)

The small cumulus clouds are arranged here in parallel lines, called cloud streets. Notice the rapid change of size as they diminish towards the horizon. (*C. S. Broomfield*)

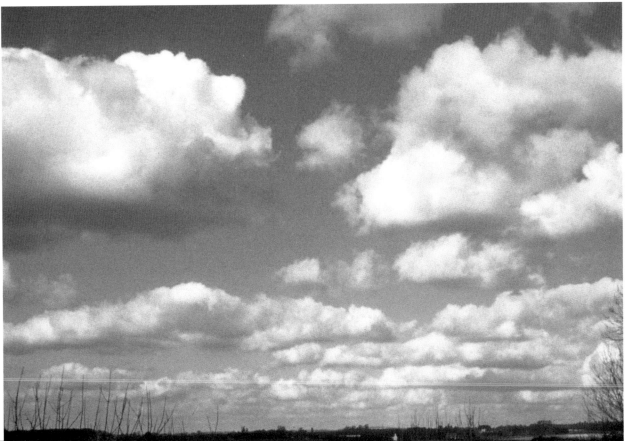

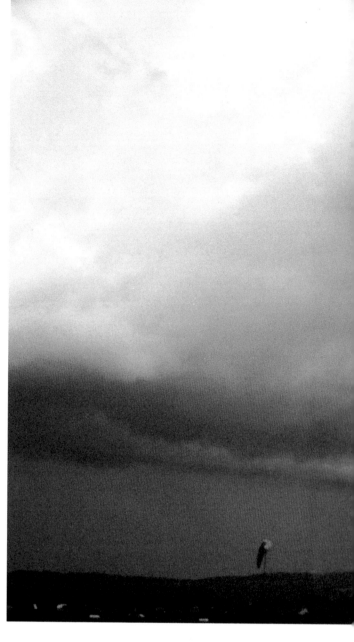

Although cumulonimbus clouds (right) often present an anvil shape, you have to be in the right position to see it. If the clouds are directly above your head, the shape is not apparent. These skies, being darker and more threatening in appearance, give good opportunity for richness and texture in a sky. (*S. D. Burt*)

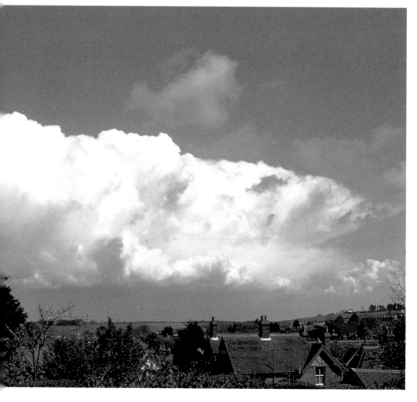

The characteristic anvil shape is clearly seen here, giving a strong vertical element, which would lend itself well to a portrait-shaped painting. (*R. K. Pilsbury*)

Stratocumulus clouds (right) often occur in patches or layers composed of rounded masses or rolls. Sometimes the elements lie in parallel bands, with light gaps appearing between them. Due to perspective, the bands may appear to converge towards the horizon.

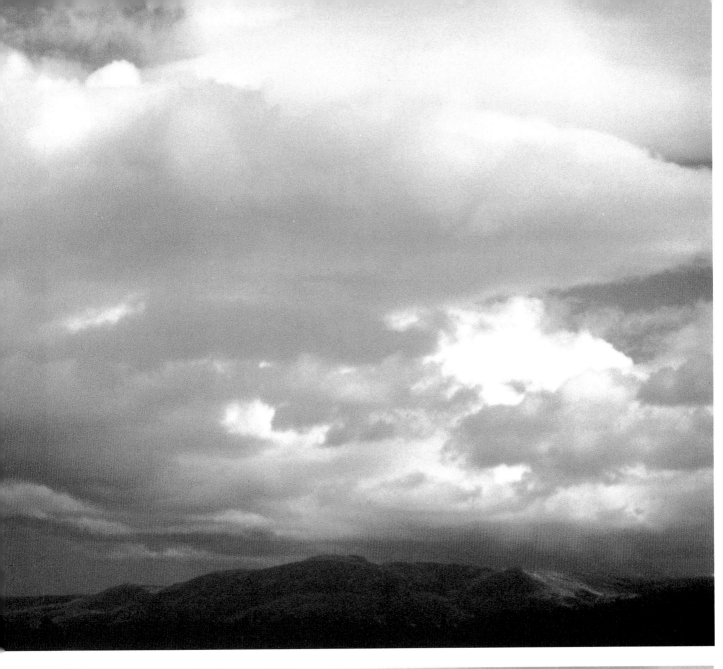
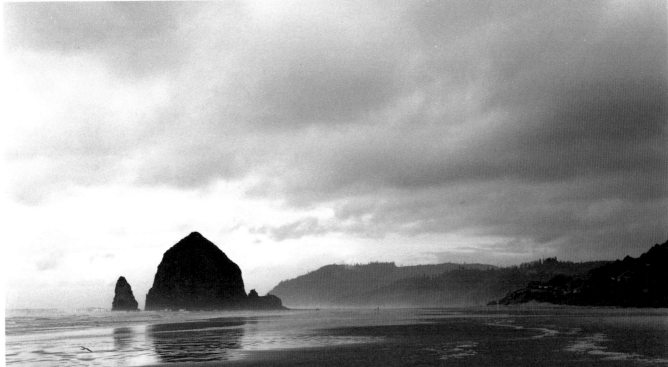

Materials

I'm not going to bore you with long lists of materials which you must buy. I find that life is much easier if you have just the bare essentials. The fewer materials you have, the less you have to worry about, but do always try to use everything to its utmost potential.

COLOURS

For years I've taught watercolour painting using a mere seven colours, regarding them as good friends rather than just acquaintances – you quickly learn how they react together. Having said that, in producing this specialist book on skies, I realized that I needed a few more friends! My old faithfuls are raw sienna, cadmium yellow (pale), burnt umber, ultramarine, light red, alizarin crimson and Payne's grey. To these I've added cerulean blue, Prussian blue and burnt sienna. These can be bought in large (21 mm) Winsor & Newton tubes of Cotman colour. I find that these tubes, which are much less expensive than the Artists' Quality ones, are conducive to squeezing out paint with greater abandon – something I'm constantly trying to persuade my students to do. So many people seem to turn into misers over their paint!

Let me tell you a little about my seven original colours.

Raw sienna. This is my 'banker'. It's very versatile and I use it on every painting, beginning each sky with it. It's an 'earth' colour – one of the oldest colours known. I much prefer it to yellow ochre, as it's much more transparent.

Cadmium yellow (pale). Probably the brightest, purest yellow you can find.

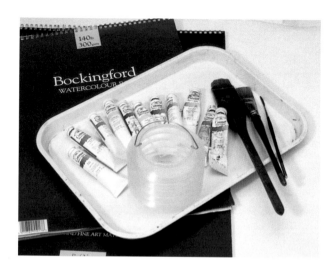

This shows my plastic tray, large tubes of colour, three main brushes, collapsible water pot and Bockingford pads, which I always have in two sizes.

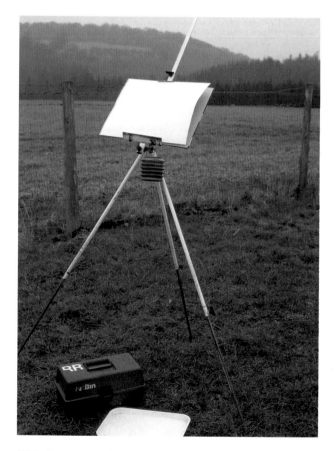

This is my outside set-up. Metal easel, art bin and palette, all of which I can carry under one arm. Note how the collapsible water pot hangs on a hook near the pad.

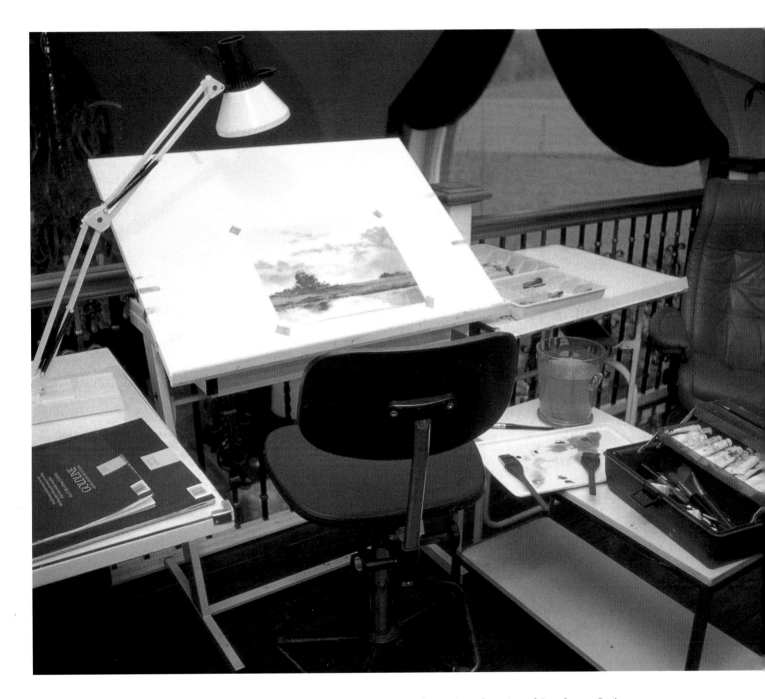

Although I have a large studio where I do my teaching, I often prefer to work at this personal work station, which I've set up in the gallery overlooking the drawing room. It has a large overhead skylight and to the right, as you can see, there's a north-facing 5.5 metre (18 foot) window overlooking the Forest of Dean. I've been using the same low trolley and large glass water jar for years now. The trolley is just the right height for mixing paint and there is plenty of room underneath for spare palettes, paper, etc.

Burnt umber. Another 'earth' colour. It is very useful for making a whole range of greys when mixed with ultramarine – so necessary for clouds.

Ultramarine. This is a very strong, warm, rich blue. I hardly ever use it straight, as it can look crude, but tempered with other colours it's delightful. For example, mixed with light red it makes lovely warm, mauvish cloud shadows.

Light red. This is a very fierce 'earth' colour – a little of it goes a long way. Never use it without adding another colour, such as raw sienna.

Alizarin crimson. Again, a tube of this lasts a long time. It's a cool, intense red and very useful for tempering down Payne's grey for clouds – a combination I probably use more than any other.

Payne's grey. Some artists wouldn't be seen dead using this colour, but I love it. Never use it by itself, though: it looks too cold and dead, and can easily dominate a painting. But applied sensitively and warmed up with colours like burnt umber, it's valuable. I use it also with yellow for my dark greens. It dries much lighter than it appears when wet.

Now to the three newcomers to my palette for skies. In the past I always used ultramarine, which is basically a warm blue, but now I feel the need of a couple of cooler blues. Cerulean is excellent – its name comes from the Latin for sky blue. And Prussian blue, although fierce, when watered down is very useful indeed. Finally, burnt sienna is the reddest of the 'earth' colours; it is permanent and a marvellous mixer.

PAPER

As to the paper, this comes in a large variety of surfaces and weights, and every artist has a favourite surface. For the last twenty years I've painted on Bockingford paper – 140 lb weight. I find that this never needs stretching – an irksome task as far as I'm concerned. Available in five weights, it has a single, unique 'Not' surface (i.e. not hot-pressed). It has a good 'tooth', which I find suits my style. It also takes kindly to correction, whereas some of the more expensive papers seem to be rather unforgiving. I usually buy the spiral-bound pads, as they're so handy to carry around. I'm not keen on the blocks, as they're inclined to cockle and can be a pain to cut out.

BRUSHES

My choice of brushes may seem somewhat eccentric, but they've served me well over many years. Originally I used the 2 inch Japanese hake made of goat hair. However, my own English Pro Arte $1\frac{1}{2}$ inch hake, also in goat hair, is more comfortable. This brush covers the surface quickly and its size helps to avoid that awful 'fiddling'. In fact, I seldom use any other brush for skies. For the rest of the painting I use a combination of hake, 1 inch flat and rigger, and have sometimes found a large round useful. The 1 inch flat is synthetic fibre and has a knife edge when wet – ideal for buildings, boats and sharp edges generally. The No. 3 rigger I use for branches of trees, grasses and figures. The round brush is a size 24, of synthetic fibre, and is also from Pro Arte.

MISCELLANEOUS MATERIALS

Sponges are useful; you'll find natural ones are far gentler than synthetic types and disturb the paper less. They're good for softening and modifying cloud shapes. I normally hate using masking solution, but it can be useful on some skies, especially if you're attempting a free sky round a complex object such as a church or a windmill. A word of warning: don't try to remove it until the paint around it is completely dry. This may sound obvious, but believe me, I've ruined many a painting due to impatience.

A word about charcoal. This is ideal for making rapid impressions of skies. The willow sticks are thin and snap easily, but this will help you to develop a light touch as you try not to break the stick! It's a beautifully expressive medium, capable of delicate blending and strong contrasts. Use this with cheap drawing paper as a preparation for your watercolour painting.

Erasers are useful in sky painting too, especially to get those rays of light below clouds which every student wants to produce. They come, of course, in various grades. Putty erasers are softest and kindest and can be used to take out pencil

marks after the painting is finished. You'll also need a soft pencil eraser and, finally, an ink eraser, which is the most abrasive. These all need gentle and careful use to avoid destroying the surface of the paper. Another essential aid, as far as watercolour is concerned, is a supply of absorbent cloths and paper tissues to blot and modify your skies.

Although I am essentially a watercolourist and most of the illustrations in this book are water-colours, I'm very aware that some of you may prefer to capture skies in other media, and you will find a few examples of these throughout the book. While I don't want to go into detail about oils and pastels, you will see on this page some of my own equipment for working in these media.

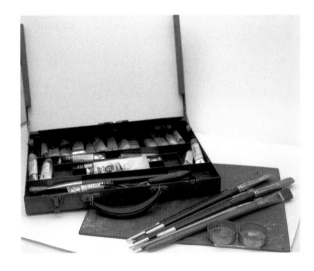

My metal oil painting box, which I bought in a church jumble sale, holds everything I need, including wooden palette, brushes and canvas board.

These are the various boxes of pastels which I'm using at present. For skies, one needs to buy soft greys and blues, individually, as these more subtle colours are not found in the boxed sets. I use the charcoal sticks to draw skies, and find the paper stump useful for softening. They are also excellent for tonal sketches. Also shown is the pad of variously coloured pastel paper. You'll find a putty eraser useful too.

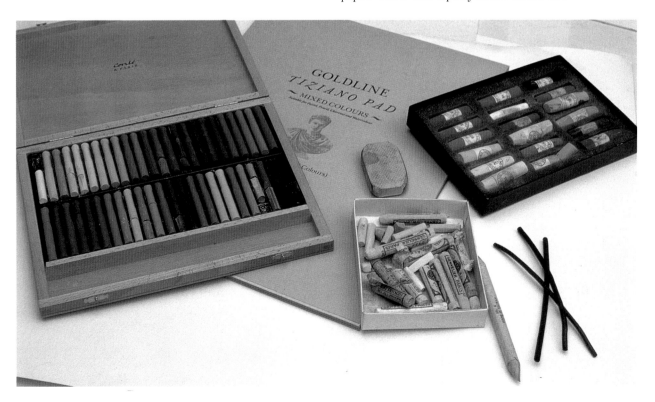

Skies in
Watercolour

The approach to painting skies in watercolour has to be quite different from that for any other media. Although watercolour is so exciting and stimulating, it is also rather unforgiving. In other media it's possible to build up your sky methodically, but a watercolour sky needs to be immediate, fresh and spontaneous. Edward Wesson used to say, 'It's only where we find we have to tinker about afterwards, adding a bit here and a bit there, and in the process gradually obliterating the liveliness of the paper, that we will know we've failed.' (Incidentally, Ed, like me, almost always used Bockingford paper for his watercolours.) This temptation to 'tinker about with it afterwards' is almost inevitable, so you must discipline yourself to leave well alone. It's much better to have a fresh sky with a few flaws in it than a tidy sky which is overworked. One of my favourite skies is shown on pages 34 and 35. You'll see that there are 'runs' and 'blues' in

I painted this tranquil autumn scene very much wet into wet, as I tried to capture the lingering mistiness of a sunny morning. The timing and strength of paint are the biggest factors here. There is a certain amount of guesswork involved as to just when to drop in the next stage, but your guesswork will get better the more you do. The sky was put in as a wet raw sienna wash, followed by a gradated mixture of ultramarine, with a touch of light red. The distant hills are a mixture of ultramarine and alizarin, put in just before the sky had completely dried. Then came the trees on the left, with a mix of raw sienna and light red. For the darker trees on the right, I made a richer mixture of light red and ultramarine. It's surprising how few colours are needed for a scene like this. The secret is to use them in different strengths. If you get the mixtures just right, the result is a very harmonious painting.

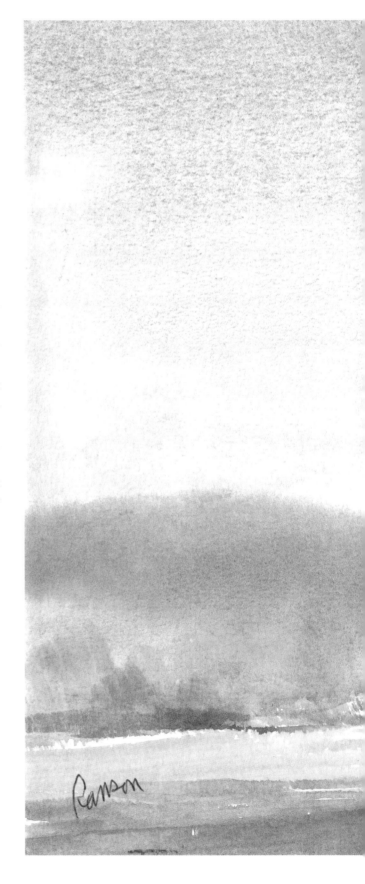

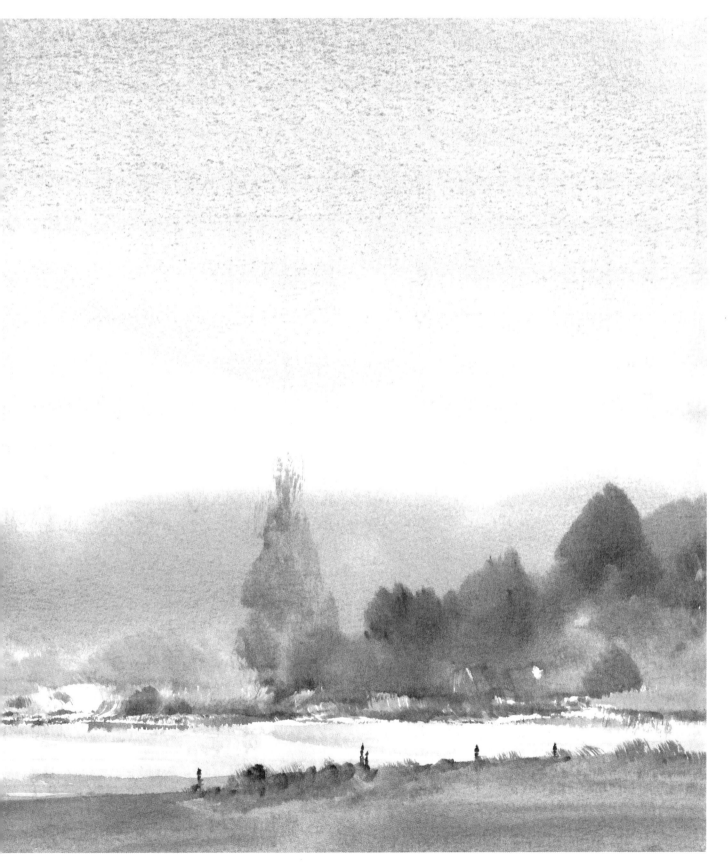

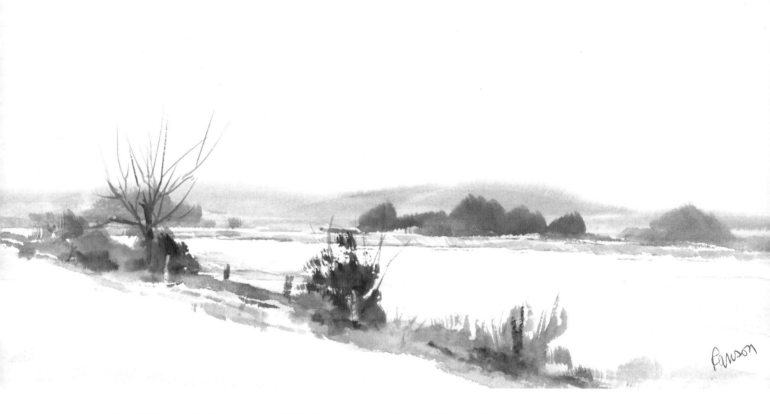

it which could have been tidied; but then the spontaneity would have been completely spoiled. You really have to 'go with the flow' and learn, to some extent at least, to let the watercolour do its own thing. So let yourself go a little, take your courage in both hands and be prepared to waste some paper in pursuit of the joy of watercolour sky. Another friend of mine, Frank Webb, always says that to him having a large supply of paper is like having many tomorrows. He will always begin again on a new sheet rather than trying to rectify a bad start.

No two skies will ever be the same, but they are all a product of your skill – with just a little luck thrown in. Exciting, isn't it?

This simple snow scene was completed using only three colours: Prussian blue, raw sienna and burnt umber. The Prussian blue was dropped into a weak wash of raw sienna, with the paper at an angle to allow it to gradate. The background hills are a mixture of Prussian blue and burnt umber and mixes of these colours of varying strengths were used throughout the painting. The rigger work, which I put in last, added a touch of contrasting calligraphy. A very simple painting, but evocative of that winter's day in February.

The painting below was done on the island of
Kalymnos as a demonstration to my students on one of
the painting holidays I run. The sky was completely
clear but of course had to be gradated. The hillside was
put in as quickly and as simply as possible, while taking
care to get some variation of colour. At the time the sea
seemed impossibly dark, but the contrast increases the
sense of dazzling light on the mountains. The main
object of this exercise was to achieve a sense of contrast
and sparkle. After the painting was finished, we all
retired to the shade of the taverna for coffee and ouzo.

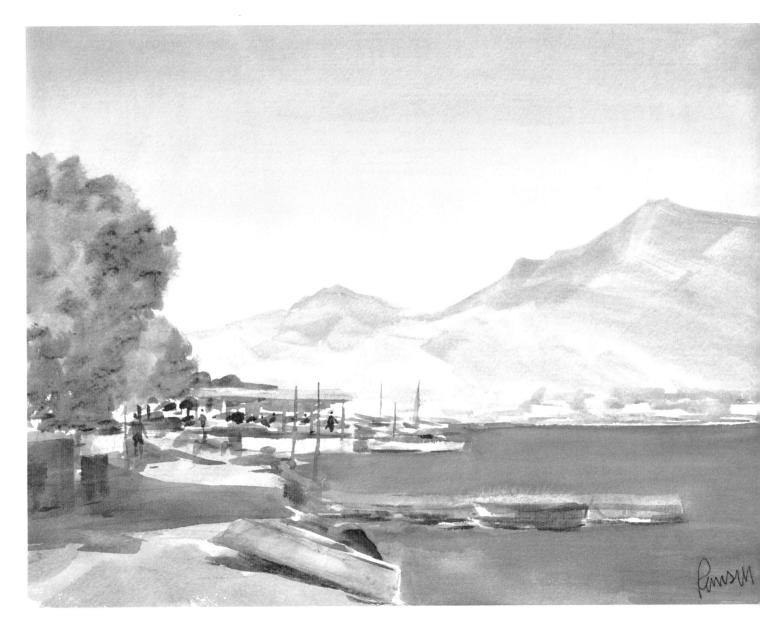

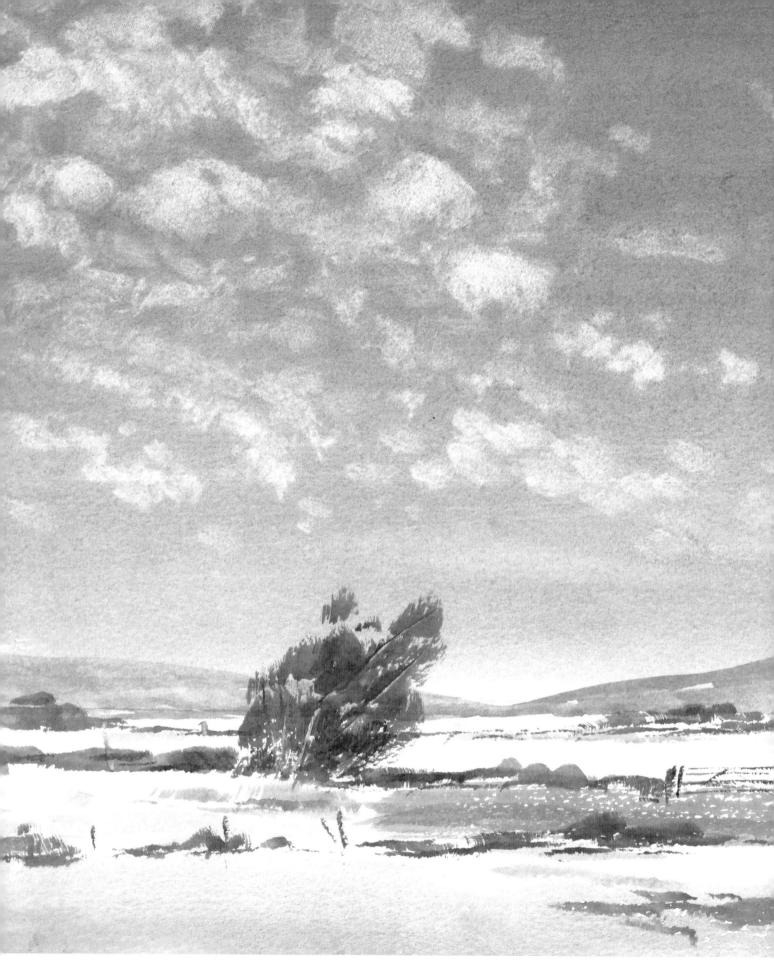

30

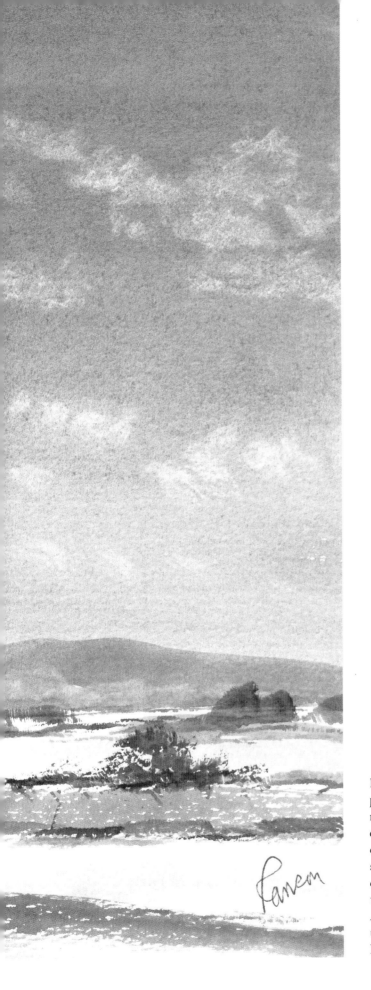

I love snow scenes, particularly on a sunny day. On this particular day, the sky was a wonderful blue with a rippling of light cirrus cloud. Irresistible! But how to capture that cloud formation in watercolour without overworking it? The answer turned out to be very simple. I dabbed the shapes out of the damp sky with a dry tissue wrapped round my finger, making sure that the clouds were larger at the top than at the bottom. Again I used a very restricted palette of burnt sienna, ultramarine and raw sienna, with just a few touches of light red.

31

SKIES IN STAGES

1. Usually I begin a sky by putting a very pale wash of raw sienna right down to the horizon. It's so pale that you may find it a little difficult to see in this illustration.

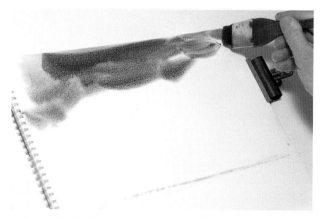

2. Immediately, I make a strong mix of 90 per cent Payne's grey and 10 per cent alizarin, and, using a whole arm movement, I put on the wash for the first large cloud. This must be done while the raw sienna is still wet.

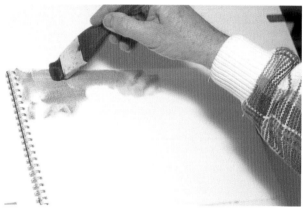

1. For this cumulus sky, after the initial raw sienna wash, the top clouds are indicated by creating negative shapes with the blue. Again, the blue should be quite strong as it goes into the still-damp wash.

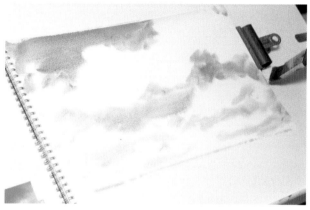

2. As you proceed towards the horizon, again make sure that the clouds are smaller and closer together. Note that one cloud is dominant.

1. In this sunset scene, the top of the sky has been gradated into the raw sienna wash and here I'm putting in the base of the sky with a mix of lemon yellow and alizarin. This too will diffuse.

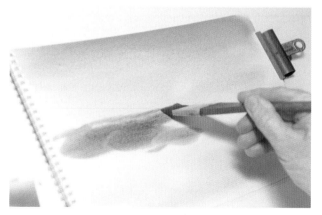

2. Now for the dominant cloud. This is put in after the paper has dried slightly, using strong, rich colour.

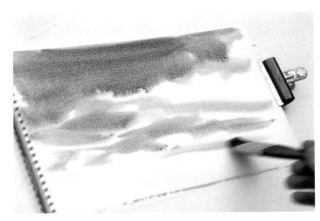

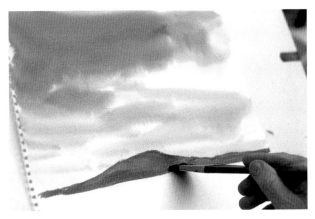

3. I then move downwards towards the horizon, making the clouds smaller and closer together as I go, rather like railway sleepers receding into the distance. If the mix is right, the clouds will begin to soften and diffuse.

4. Here you see the effect has softened and now the horizon can be painted in. If you want a softer horizon, then paint it in before the sky is quite dry. If it's a harder edge you're after, then leave it longer.

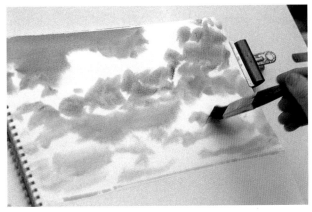

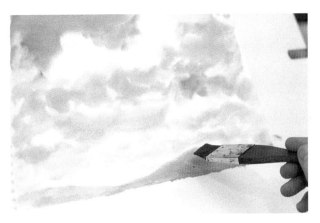

3. Now is the time to put in the shadow underneath the clouds. You need to work quickly, giving each cloud its individual shadow before the initial raw sienna wash is dry.

4. You can see how, due to the dampness of the paper, the clouds and their shadows have weakened and diffused. The horizon can now be put in.

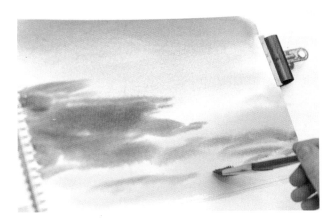

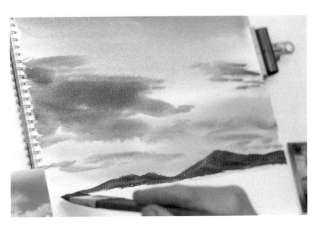

3. After the first cloud, smaller and flatter clouds are introduced towards the horizon, giving recession and perspective.

4. The clouds having diffused, the horizon can now be introduced, remembering that in a sunset situation the horizon will be quite dark.

I have to admit that this painting came straight out of my head. However, it has about it an air of spontaneity and freshness which I strive for in all my paintings – although not always successfully! I so often look at a painting and think, if only I had not gone back and fiddled with it. This time I was determined to leave well alone. We all seem to have this urge to 'improve' a wash, and usually the result is disastrous!

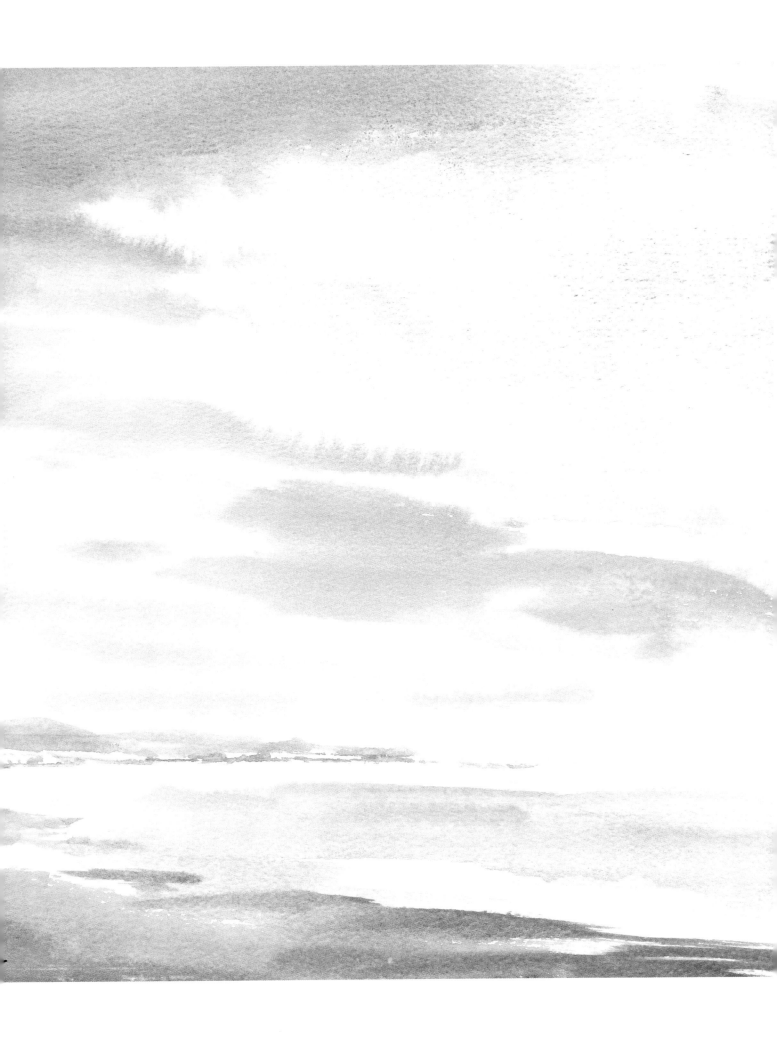

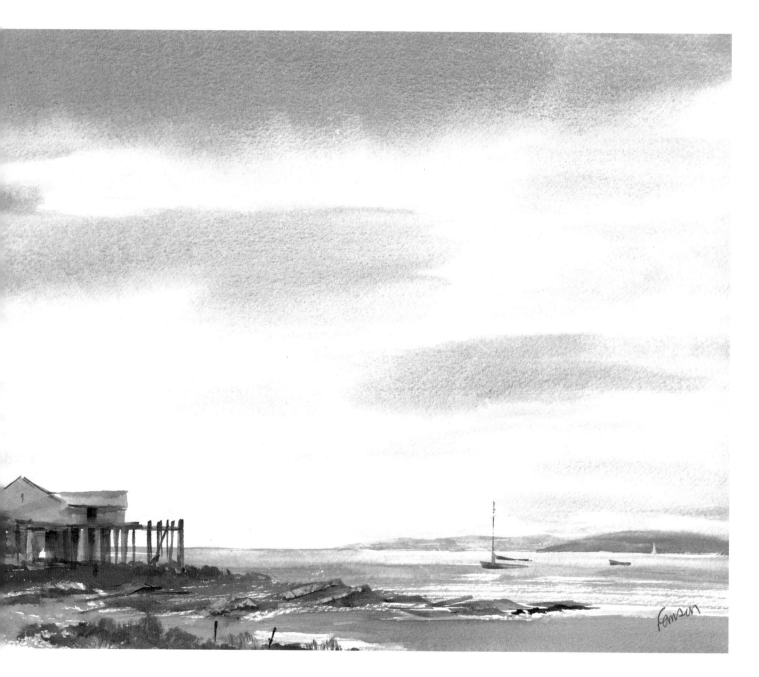

This wispy cirrus sky was very simple to paint, but you must employ a certain amount of dash and verve to retain the freshness – then leave it alone! Into the first raw sienna wash I dropped a mixture of ultramarine and Payne's grey, remembering that the clouds are created by negative space. As always, the clouds must diminish in size as they approach the horizon.

This is one of those lovely cumulus cloud formations which build up and dominate the whole sky. The characteristic flat bottom is apparent here, as is the cauliflower shape at the top. To achieve this top shape you have to time the blue wash so as to get strong definition without a hard line. The sky colours are repeated in the landscape below: for example, the pinks and blues.

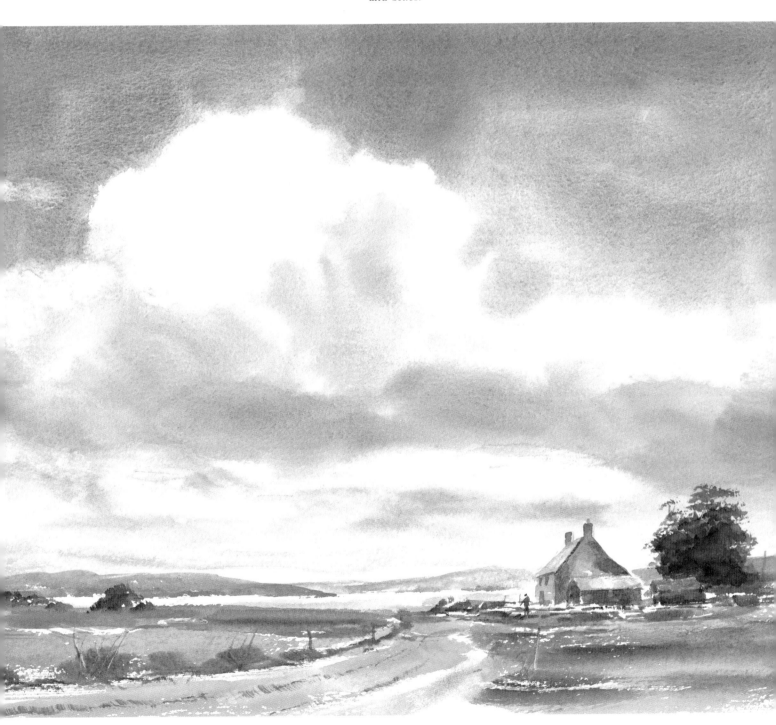

Another example of cirrus cloud, this time in a late afternoon sky with plenty of colour variation. Again the main clouds were taken out with tissue, but using the whole arm for the painting to give a free yet definite directional feel. The setting sun floods the whole foreground with a warm light.

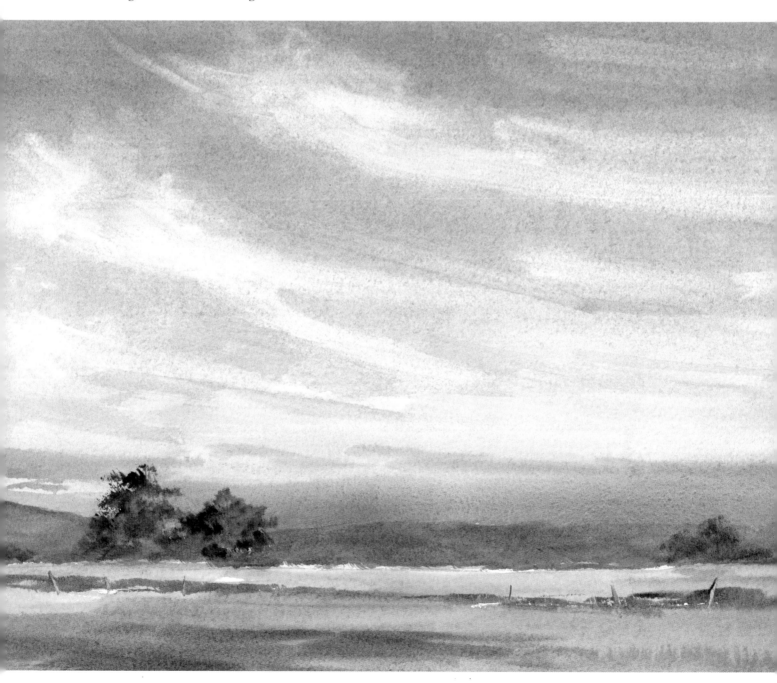

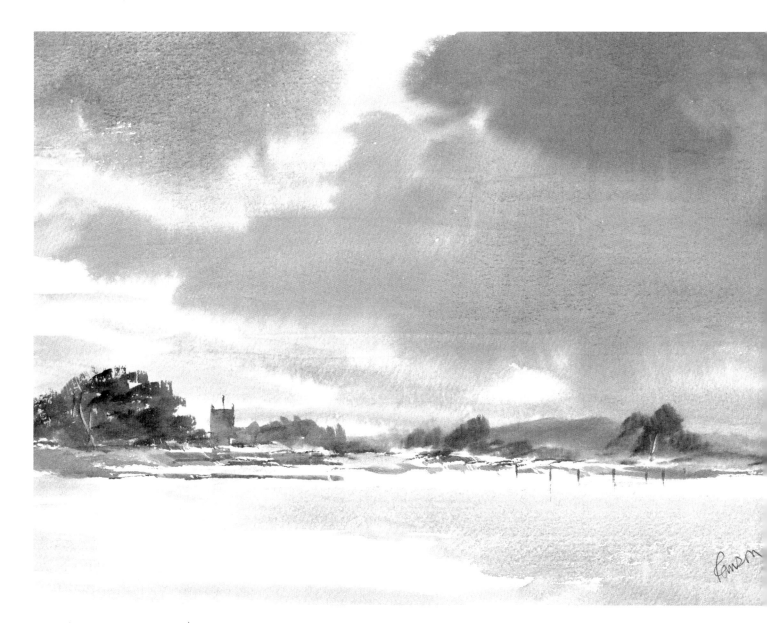

There is plenty of wet into wet about this painting, giving very soft edges to the clouds. The strong mixture of Payne's grey and alizarin was put on and then allowed to diffuse down the steeply sloped paper. Before this was quite dry, I put in the distant hills and right-hand trees, but allowed the washes to dry before putting in the church and left-hand trees. The shadow on the snow was painted in lightly and quickly. Never go back to snow shadows; they must look like a virgin wash.

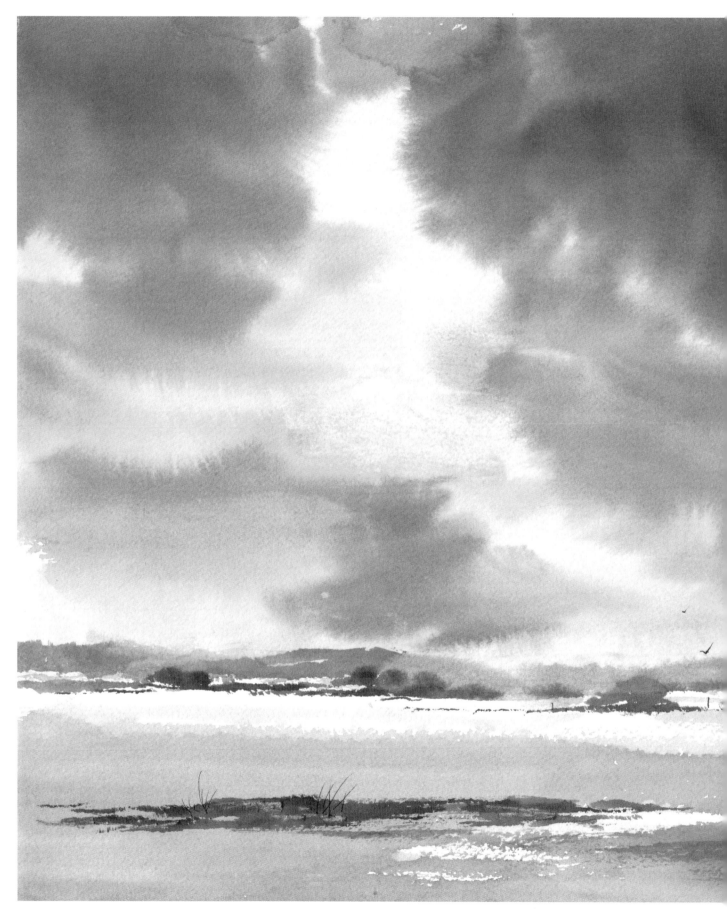

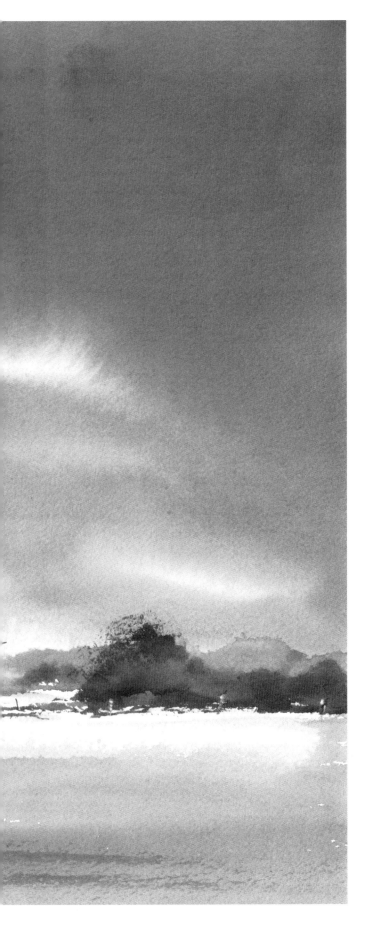

Skies on Location

You're probably tired of hearing from one or another artist that you should paint a sky a day. Although it's good advice, most of us are never able to put it into practice.

If you are serious about developing your sky painting, the first thing to do is learn to draw them. For this, you need much less equipment than usual. A spiral-bound sketchbook and a soft pencil are really sufficient. However, if you want to experiment with charcoal, you'll need a putty rubber and a spray fixative as well. It's a good thing to keep this one sketchbook entirely for skies, and always have it with you. It will soon become a valuable source of knowledge and reference.

Perhaps it is best, at first, to choose skies with just a few simple clouds, then build up from there until you can handle massive or complex cloud formations.

Now you're outdoors, don't be in too much of a hurry to put pencil to paper. Attempt to familiarize yourself with the changing patterns. Forget about the scene below and concentrate exclusively on the sky. The first decision you must make is what direction the light is coming from. Then you need to know which way the clouds are moving. Even if the clouds are moving fast, don't

This late winter's afternoon simply glowed as the gold of the sky was reflected in the snow. There's very little white in a picture like this and colour harmony is the most important factor. Unusually, I used a small amount of cadmium orange in the sky to give impact. The rest of the sky was very much wet into wet, with the mauve clouds being allowed to diffuse on the steeply angled paper. The more you tilt the paper, of course, the faster the wash will run. There is a certain amount of 'lost and found' in the distant woods. The use of dry brush in the snow contrasts well with the wet into wet sky.

There is nothing quite as satisfying as painting on location – once you've found a suitable subject!

try to rush, since most of the shapes will be repeated again and again, rather like the patterns found in a fast-moving stream. Don't try to include everything you see in the sky, but select the part with the most interesting cloud formations. When painting outdoors, I've often painted the landscape in front of me but the sky from behind, because it had the most interesting shapes and patterns.

Once you've had a good look, decided on the light source and the direction of cloud movement, you can begin the drawing. Start in the centre of the paper, to give yourself more freedom as the clouds move. At this stage, ignore the detail and simply attempt to indicate the main cloud shapes.

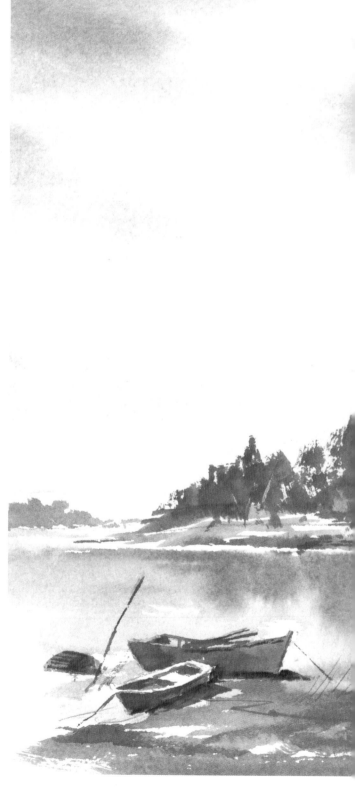

I visit the coast of Maine each year to teach in the lobster-fishing village of Port Clyde. It is surrounded by islands and estuaries, which are a delight to any painter. Much of the painting was done wet into wet, including the foreground and sky. A sky like this needs to be done standing up, using a free whole arm movement. These broad sweeps add a strong feeling of movement, as a contrast to the static boats. The calligraphy of the foreground grasses provides a satisfying foil to the wet into wet of the water.

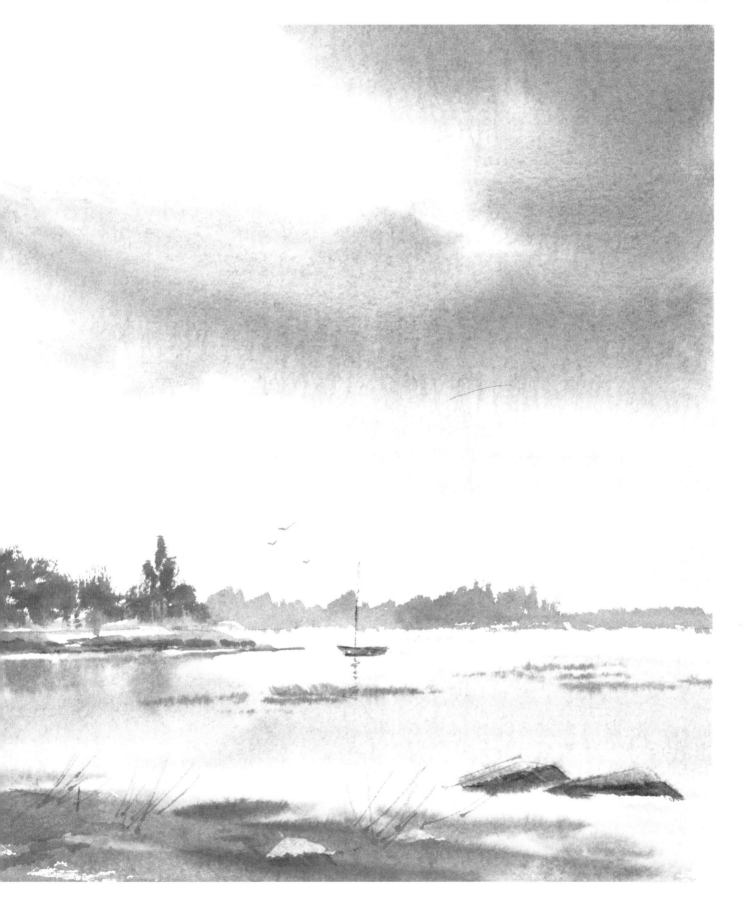

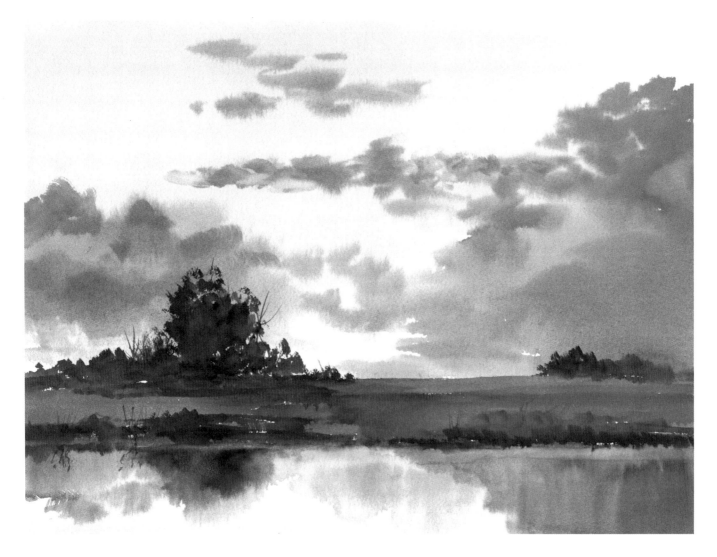

More difficult is the problem of comparing the darkest tone in the sky with the darkest part of the landscape. You'll find that the sky is never as dark as the landscape, except during a storm. After all, the sky is inevitably the source of light. It is always better to err on the light side when you're shading the clouds. Too strong a tone will detract from the shape and character of a cloud.

As with all tonal sketches, keep them relatively small. That way they will be much easier to control. While on location, stick to the facts and put down only what you can see. Back in the studio, you can use your imagination and memory to build free and dramatic skies. Confidence will grow rapidly with practice, so keep trying!

Moving from pencil to charcoal, there is room here for experimenting. Try using your fingertips

As many of you will have realized, I love what I always think of as Seago country – the Norfolk Broads – and no year would be complete for me without at least one visit. Because of the flat landscape, the skies assume a greater importance here than anywhere else I know of. This is a view looking across the River Thurne in the late afternoon. I used Prussian blue at the top of the sky, allowing it to merge into the original raw sienna wash. I then added the clouds while the mixture was still damp.

and putty eraser to take out the light clouds from the medium tones. All this drawing will have improved your knowledge of skies and cloud formations, and with this under your belt you are ready to go outside with your watercolours.

You don't want to make life more complicated than it need be, so keep your equipment to the

minimum. Aim to be able to carry the whole lot under one arm, but check that you have the essentials. My own check list reads as follows: plastic art bin containing soft pencil, tubes of paint, three brushes, collapsible water pot, plastic bottle of water, rags and two spring clips (for holding the loose corners of the pad down). Besides the bin, I have the Bockingford pad, with a hardboard backing, plastic palette and metal easel.

Once you've established your site, have everything close at hand. Hang your water pot on a hook just below the pad, so that it's instantly available. Personally, I prefer to stand at the easel, particularly when I'm painting clouds. It gives much more freedom of movement. Try never to have the sun directly on your paper. Apart from the discomfort of having to screw your eyes up against the light, it makes judging tones much more difficult and the painting will look 'washed out' back in the studio. The second you feel a spot of rain, turn your paper over. Even a faint drizzle will ruin your sky in seconds!

In this Welsh estuary scene the sky was lively and exciting, with clouds on different levels. Into the original raw sienna wash, I painted the blue of the sky. The cumulonimbus clouds below are a mixture of wet into wet and have edged gaps, helping to create the breezy conditions. Note how the colours in the beach echo the clouds, and the distant hills take on the blue of the sky, all helping to promote a sense of unity.

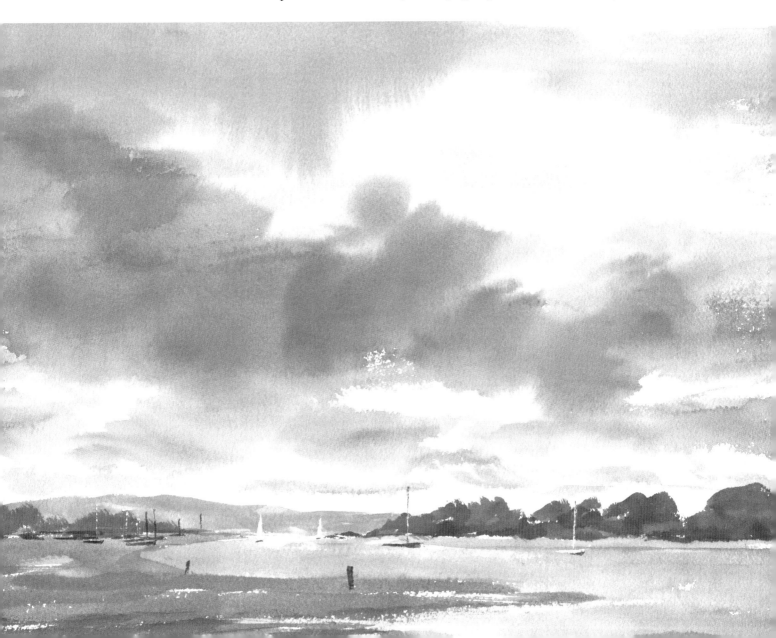

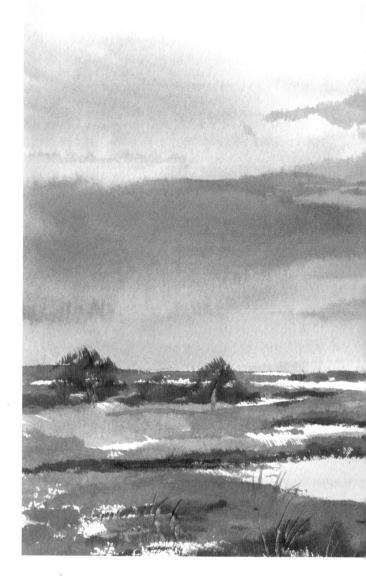

We're back in Maine now, this time looking inland with my back to the sea at high tide. At low tide there would have been only a trickle of water down the middle of the channel. Although there were clouds at many different levels, they were fairly static, and the scene was very peaceful and still. Although it is tiny, the distant dinghy attracts the eye, positioned as it is as the darkest dark against the lightest light. Also, of course, it's the only man-made object in the scene. The lighting in the sky was interesting. The sunlit cream of the distant cumulus contrasted well with the deeper colours and all were reflected in the water below. I've continued this into the foreground grasses.

We discussed in the last chapter the basic techniques for the various cloud formations, although when you're in the great outdoors these won't fall into neat categories. As you look in different directions, you may see mixed skies. In one area you may see cirrus on top, with stratus underneath. Don't try to paint the sky from one horizon to the next; just choose one small area which has a particularly interesting pattern.

Turning to practical matters, now of course you'll need more equipment. I always use a good, strong, metal Italian easel, very simple and requiring little effort and skill to erect, unlike some wooden ones I've seen. On the easel, I have a hardboard backing for the watercolour pads, then I tip the board to at least 45 degrees. Gravity can be a useful ally when you're painting skies. I could not even contemplate painting a sky on a flat surface. Because I'm often demonstrating to a crowd of students, my board may be even steeper, at about 70 degrees. As I've said before, you will need to be painting quickly, so have all your basic colours ready. Raw sienna, Payne's grey, alizarin and blue are, I find, sufficient for most skies. The only other materials I've used in the paintings you see here are my hake, water and a rag. I find the collapsible pot I use for water invaluable.

As with the sketches, it might be a good thing to have a watercolour pad just for skies which can be kept and used as reference for future pictures. So often we're faced with a boring, flat sky in front of us when we're painting landscape. This is when your reference pad will come into its own.

Accept at the outset that there are going to be failures. There is no doubt about it, watercolour is much more difficult to handle than just pushing a pencil around. Inevitably you're going to use too much water at first, and your clouds will sag and run. It's vital to compensate for the water content in the first wash by making the following wash stronger than you think it should be. A good quote to remember is, 'If a wash looks right

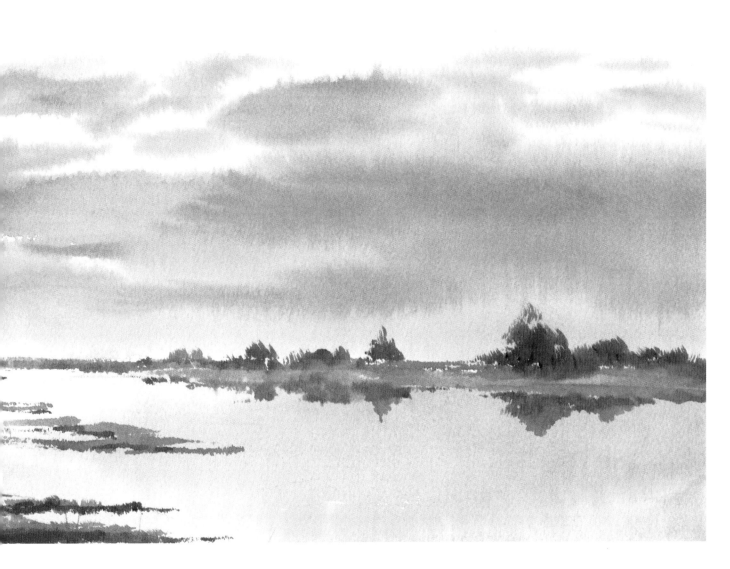

when it's wet, it's wrong when its dry.' In other words, watercolour, especially in skies, always dries lighter than when it is first put on. Speed too is essential. It's no good letting your first raw sienna wash dry while you're mixing the second. In fact, these are the two things you really have to work at: water content and speed. They will come only with confidence, and the more you practise, the more confident you will become. Select the essential features of the sky for your painting and simplify them by working with the big brush, quickly and decisively. Giving yourself a time limit of, say, fifteen minutes could also help.

You'll be surprised at how soon you'll be working with increased confidence, authority and – very important, this – pleasure!

Although this chapter is very much water-colour-based, many of the principles apply equally to oils and to pastels, and you can see my 'outdoor kit' for these media in the chapter on materials. However, my metal easel is so adaptable that it can, in fact, be used for any medium.

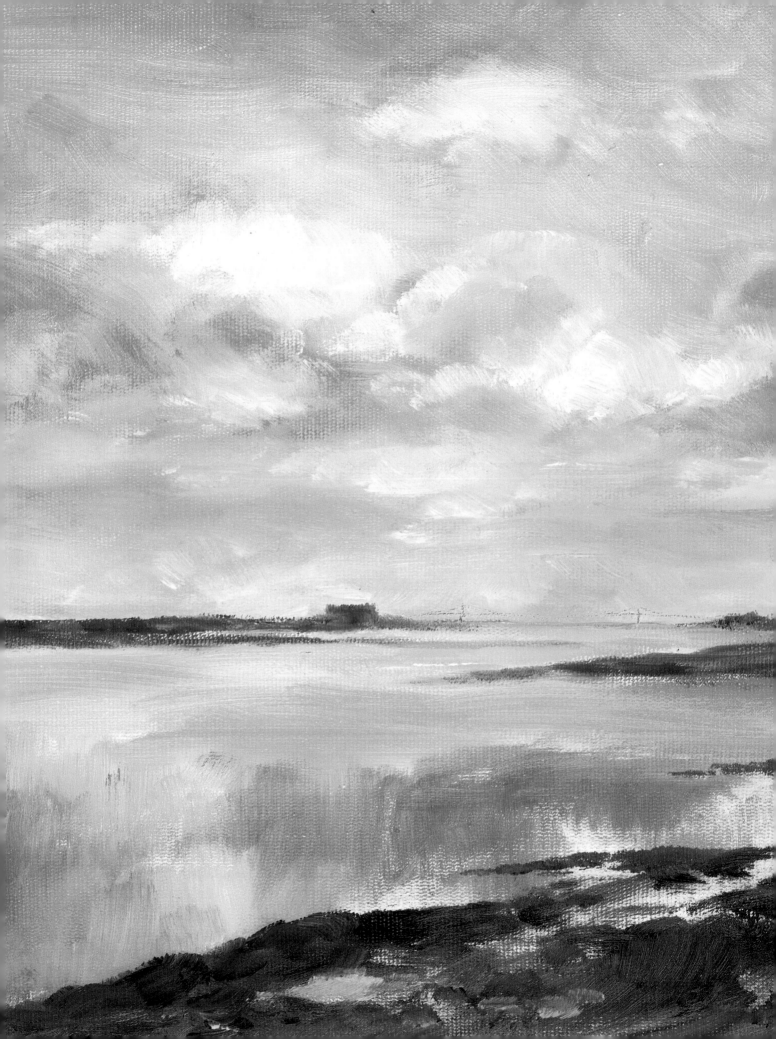

Skies in Other Media

For many years my painting career was centred around watercolour. I've always loved its challenge, as one attempts to produce fresh, free paintings, while avoiding the constant temptation to overwork, which always results in muddiness. More recently, though, I've been attracted to working in other media, and I feel that a book devoted entirely to skies deserves at least one chapter showing the use of these different materials and techniques. While accepting that these other media present a completely different set of challenges, by their very nature oil and pastel are at least more forgiving than watercolour. One is not generally subjected to the instant failure which lies in wait for the watercolourist. I have enjoyed being able to employ a more measured, calmer approach, and not having to worry about negative shapes to preserve the lights in the skies. Turning first to pastels and their use in sky painting, of course you can't mix up the colours on a palette as you can with watercolour or oils, but instead have to rely on the subtlety of each individual pastel. You can't just go out and buy a box of pastels; you have to choose each colour very carefully. This is particularly so when you're concentrating on skies. The colours in the boxes that are already made up simply aren't subtle enough.

This oil painting was done very close to home at Lydney Docks on the Severn estuary, looking towards the Severn Bridge. This once-thriving port is now virtually deserted, but offers great opportunities to paint undisturbed, with its huge vistas of sky and water. I was particularly attracted by the reflections of the sky in the water and the light on the mud flats, which were anything but a dull, flat brown and presented quite a challenge.

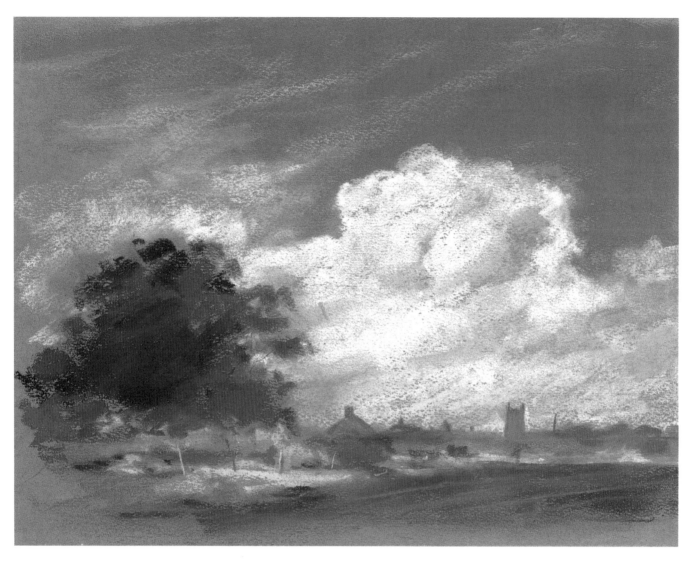

This pastel depicts two types of cloud – high-flying cirrus and a strong, billowing cumulus below. Notice how the cloud shape is repeated in the foreground tree, giving balance and harmony to the scene, while the counterchanged profile of the village adds interest and gives a focal point.

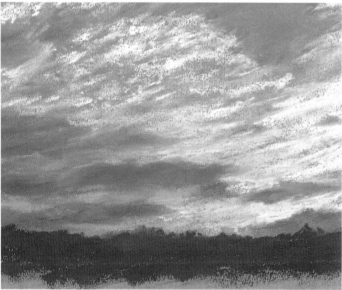

What attracted me here was the opportunity to use some strong pastel colours to depict the evening sky. The variety of clouds was good too. There was a mackerel effect above, with stronger cumulonimbus below, beautifully lit by the setting sun and enhanced by the strong, dark, crisp profile of the trees on the horizon.

It's a wonderful excuse, though, to spend time browsing through the art supplies shops, choosing delicate mauves, pinks and creams. Another enjoyable aspect is that you need so little equipment, which makes it perfect for working in the field. Although it is possible to use watercolour paper, there is a wide range of pastel paper available; Canson and Ingres are two of the most famous names here. One can also use very fine sandpaper.

I feel that one of the dangers in pastel is the temptation to attempt continually to soften the pastel with your finger. While this is, of course, necessary in some parts of a painting, it can never be a substitute for good strong individual strokes, which give vibrancy and life to a painting.

With respect to oils, I've enjoyed being able to build stroke on stroke – impossible in watercolour. There are so many different techniques one can employ that there is tremendous scope for individuality. I still enjoy using large brushes, which

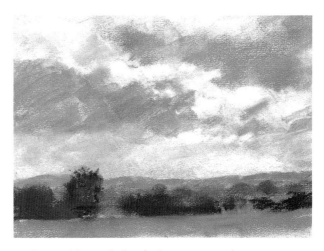

In this rapid pastel sketch, I was attempting to capture the delicate mauve and orange tints in the February sky, contrasted as they were with the richer colours of the landscape.

This chaotic sky seemed to have a little of almost every cloud type in it. I've tried to get plenty of warm and cool colours into the cloud shapes, as well as capturing the movement as they race across the sky.

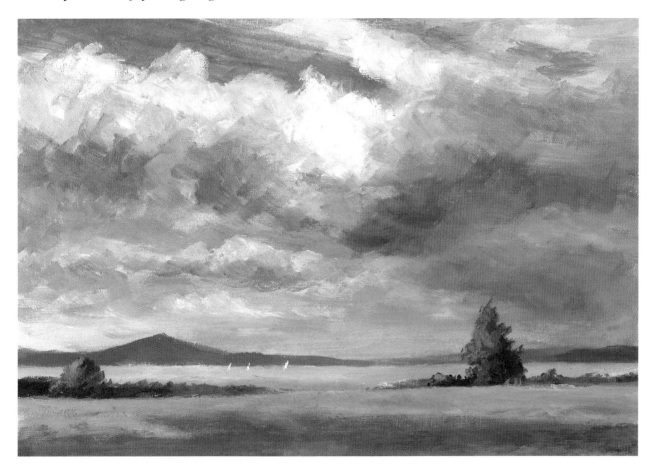

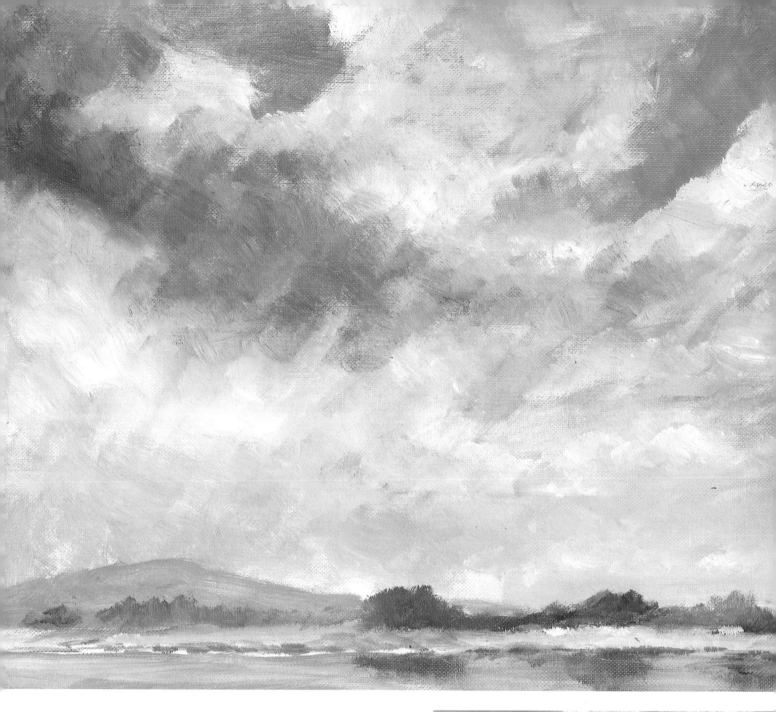

What I attempted in this oil painting was to get varying amounts of warm and cool colours into the clouds. I feel this makes for a more interesting effect than simply painting white clouds in a blue sky. The use of too much pure white in an oil painting tends to make it look chalky and rather amateurish. Keep the white for highlighting – in buildings or boats, for example.

In the 'streets' of cumulus clouds in this fresh estuary scene in pastel, I've again introduced creams and pinks into the cloud colour. This brings interest and warmth to the sky, and is repeated in the water. The moored dinghy provides a useful centre of interest.

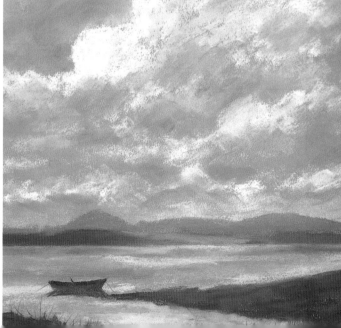

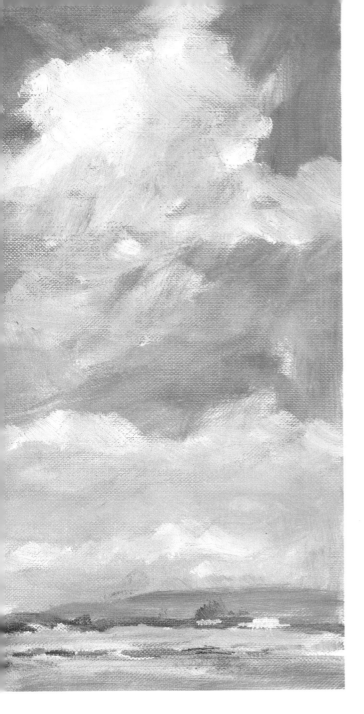

help to provide freedom. Even an oil painting will lose its vigour if one is too 'careful' with it.

Something to avoid is the over-use of pure white. Even white billowing clouds will need a touch of another colour to warm them. Regarding materials, traditional canvases seem to be less and less used, even among our top professionals, and there are many alternative supports now available. One can buy ready-prepared oil painting boards in all shapes and sizes. You could, however, prepare your own by painting the smooth side of hardboard just with size and then with gesso. This will give a good tooth to your board and is cheaper yet still stable. Rather like with watercolour painting, a restricted palette is preferable. Most of the oil painters I admire use only about ten colours.

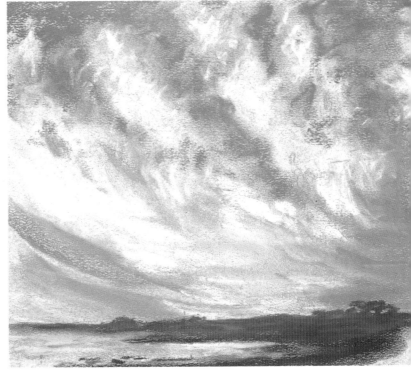

There is a strong feeling of movement in this pastel of an evening cirrus sky. An important design feature is the way in which the cloud formation points to the group of trees on the right. The sky colour reflected in the lake below provides an element of unity.

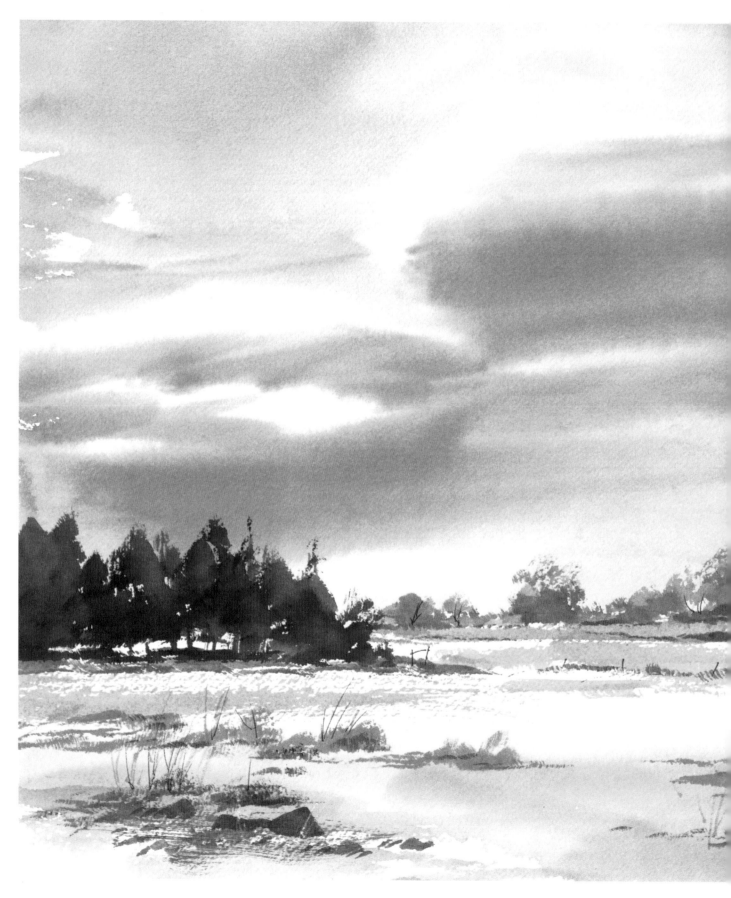

Design in Skies

You may be a little surprised at this chapter heading, but as an artist your job is not just to record but to make your sky part of a whole and unified painting. To achieve this, we have to obey the rules of design. I'd be shirking my responsibility if all I did was to show you the technique of applying paint, without outlining the basic principles of design. Artists may not necessarily be born with the ability to design, but it is something which everyone can learn. There are very definite rules which, once learned and applied, will take your painting into another sphere. Your ignorance of these rules will always show in a very negative way, while your knowledge will enhance your work no matter what the subject is.

There are eight principles which we need to think about and act on in all our pictures. These are

> Unity
> Contrast
> Dominance
> Variation
> Alternation
> Balance
> Harmony
> Gradation

One way of ensuring unity in a picture is to echo the colours, and a snow scene like this gives a good opportunity. Notice how the sky colour is repeated on the snow below. There is balance here too, the dominant cloud on the right being balanced by the dark clump of trees on the opposite side. There is variety in the foreground, the soft wet into wet snow giving interest when used against the dry brush technique, and the calligraphy of the grasses. Contrast is provided throughout the picture, soft against hard, dark against light, but is probably most noticeable in the trees on the skyline.

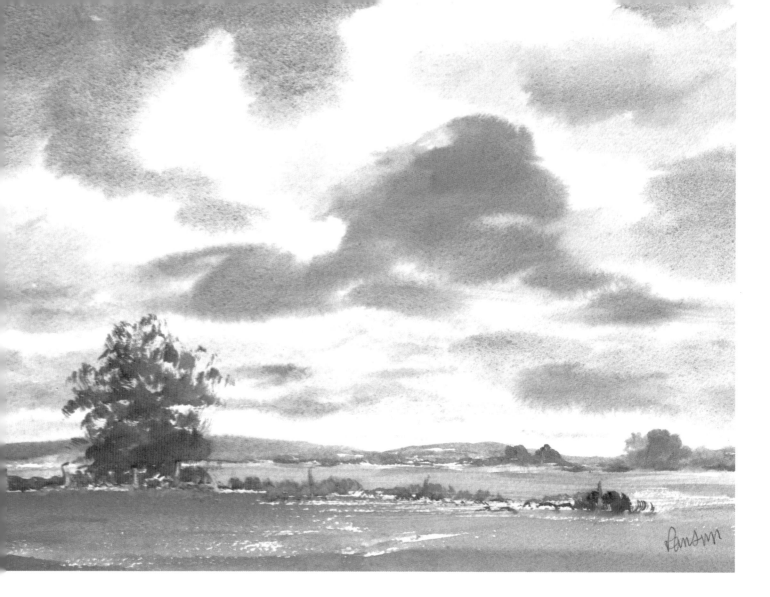

In this simple landscape many of the design principles are illustrated. The main cloud is echoed by the shape of the tree, and these two elements balance each other as well. The tree also acts as a link between land and sky. You'll notice at once how one cloud dominates the whole sky, while its darker edge contrasts well against the lighter cloud behind.

All these can and should be applied to sky painting. They're not complicated but they are vitally important, so let's look at them one at a time.

Unity. Each painting must be a complete unit, rather than a collection of disparate objects. One way of achieving this is to echo shapes or colours in a different area of your painting. For example, a cloud shape could be echoed by a tree, which would also act as a link between land and sky. These echoes shouldn't be the same size, of course; always make one larger than the other, and ideally

position them obliquely. Colourwise, always try to repeat some of your sky colour in your landscape, or vice versa. A good example would be to have some of the sky colour in the water below.

Contrast. This will create interest and excitement, and is a principle that you will need in each and every one of your paintings. You can have contrast in tone: for example, a dark tree against a light part of the sky, or a sunlit steeple against a dark thundercloud. You can use horizontal against vertical: for example, a ship's mast against a mainly flat horizon. Or hard against soft: for example, the silhouette of a town against billowing clouds.

Dominance. A good example of this would be to make one cloud in the sky larger and stronger than all the others. Nothing looks worse than a

row of uniform clouds! Colour dominance can be achieved by a larger area of one colour, or a small area of a more intense colour against a more neutral one. For example, make your blue patch of sky either larger or smaller than your cloudy area, not the same size.

There are many elements of design in this picture. You can see the unity provided by the reflection of the sky colour in the water. There's lots of contrast, with the hard, dark edge of the mountain against the sky, and the land against water. While there's plenty of richness in the colours, they are harmonious throughout the picture.

Variation and Alternation. These are ways of repeating yourself in your painting, but without monotony. For example, you could paint several cumulus clouds, varying them in shape and size – basically, large at the top and small at the bottom. Vary the spaces between the clouds (alternation), which will also help.

Balance. Perhaps the easiest example of this would be to have a dark tree balanced by a dark cloud, but always obliquely, and always a different size. You'll see this point illustrated time and time again throughout the book.

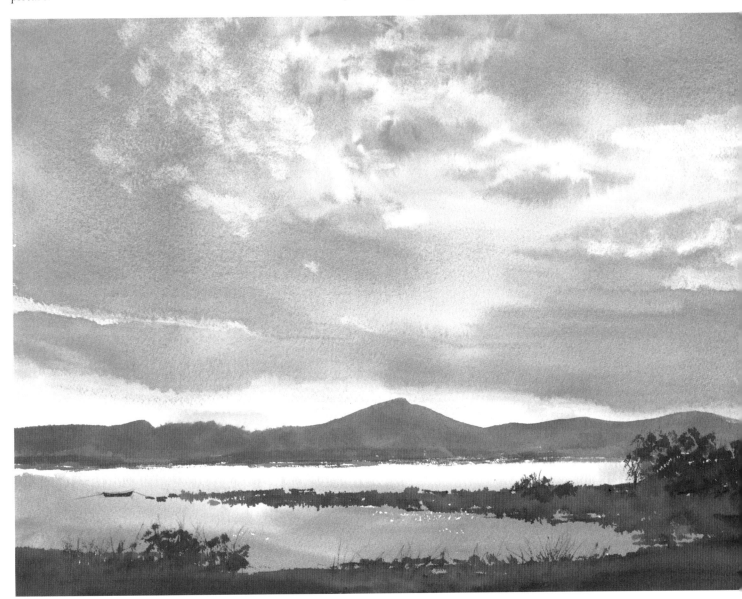

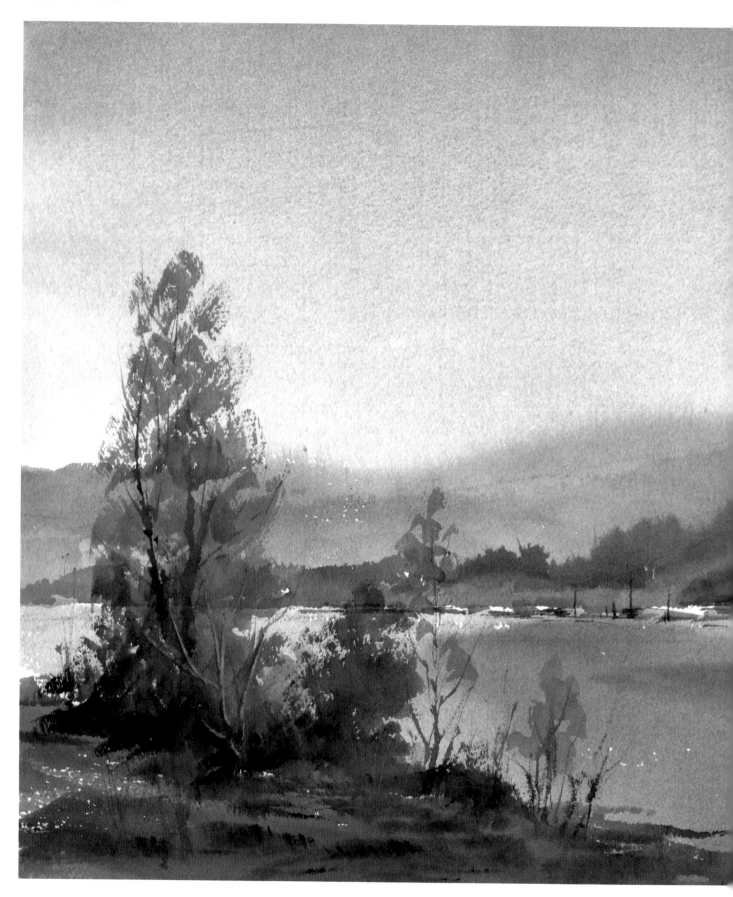

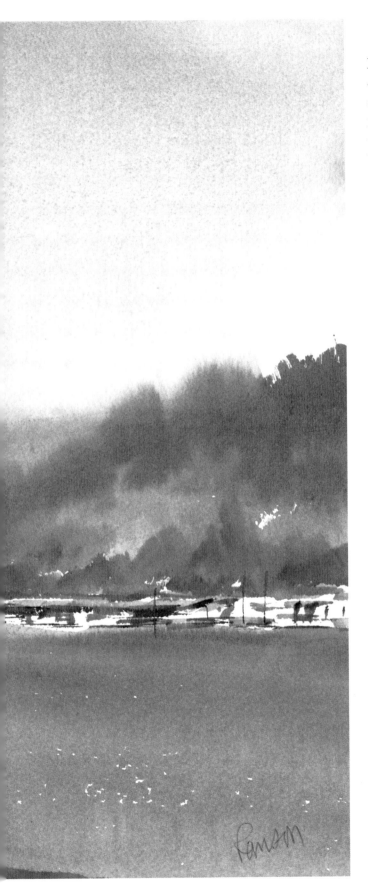

Harmony. When we talk of the harmonious elements in a painting, we mean those that are similar to each other or have affinity, like the notes in a musical chord. For example, a circle with an oval, or the colour orange with red, or a boulder in the foreground could be a similar shape to a cloud in your sky.

Gradation. Wherever you have a large area in mainly one colour, you must use gradation to avoid boredom. So, in a cloudless sky, you must grade your blue from deep blue at the top to cream at the bottom. What you're aiming for is a gradual change from cool to warm colour, dark to light, or light to dark. You can apply this, as I've said, to a clear blue sky or to one that is grey and overcast.

Not all your paintings need to contain all the principles, but try to incorporate as many as you can. Once you've absorbed these eight principles into your way of thinking about your painting, they will soon become second nature. Perhaps at first it would be an idea to keep a check list of the principles close at hand. When you think about it, they are all common sense anyway.

There are, of course, other aspects of composition which we should look at. Perhaps one of the worst *faux pas* would be to put your horizon smack in the middle of your painting. Doing this

In this misty river scene, with its gradated sky, boredom is avoided by varying the colours across the background. The colours also provide harmony. While the picture is predominantly horizontal, the main tree provides a strong vertical element, giving contrast and linking the foreground to the rest of the painting. The strongest contrast can be seen in the sharp treatment of the moored boats against the soft trees behind them. You'll notice how I've echoed the colours of the foreground tree in the patch of colour in the background hills. I felt a rare contentment while I was working on the painting, which I hope is evident in the finished interpretation of this gentle scene.

will instantly chop your painting in half, so destroying all your attempts at unification. In our paragraph on dominance, we've mentioned that one cloud must dominate but never be placed in the centre; it should always be to one side. This, of course, applies to other objects in your paintings, such as trees. Another thing to remember is, never have two objects of equal size on opposite sides of the painting. This leads us on to the importance of having a good focal point, a spot in your picture to which the eye will be inevitably drawn. It does not have to be the largest thing; it might be the area of greatest contrast or the brightest colour. One thing to remember here is that either a figure, human or animal, or a man-made object, be it a boat, house or gate, will

always attract attention, no matter how tiny it is in the picture. If you had a massive sky with just a tiny church spire on the horizon, this would be the point to which the eye was immediately drawn. This is a good principle to remember in any sky

The eye is taken into the picture via the road turning towards the distant church tower. I did the painting, which is basically of a field of stubble, at the side of a road in Norfolk. I've deliberately echoed some of the sky colour in the stubble and the road to give both variety and unity. It's interesting to note that the eye is always drawn to a man-made object in a picture, no matter how small it is. There is a good variety of warm and cool greens here, and the calligraphy of the foreground grasses provides a vertical element in a mainly horizontal composition.

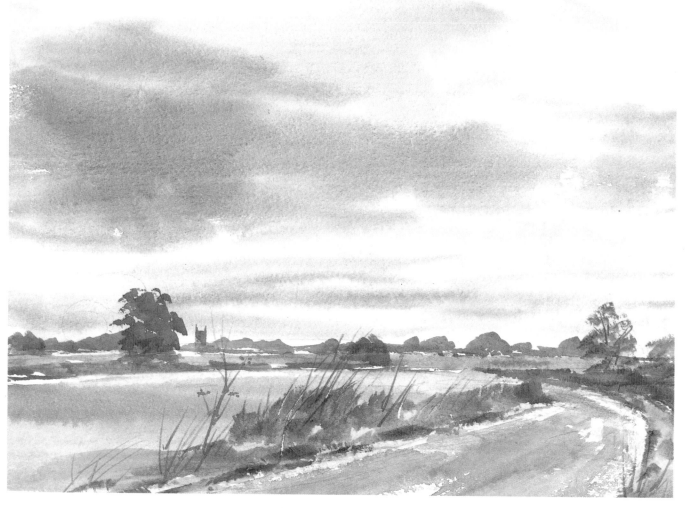

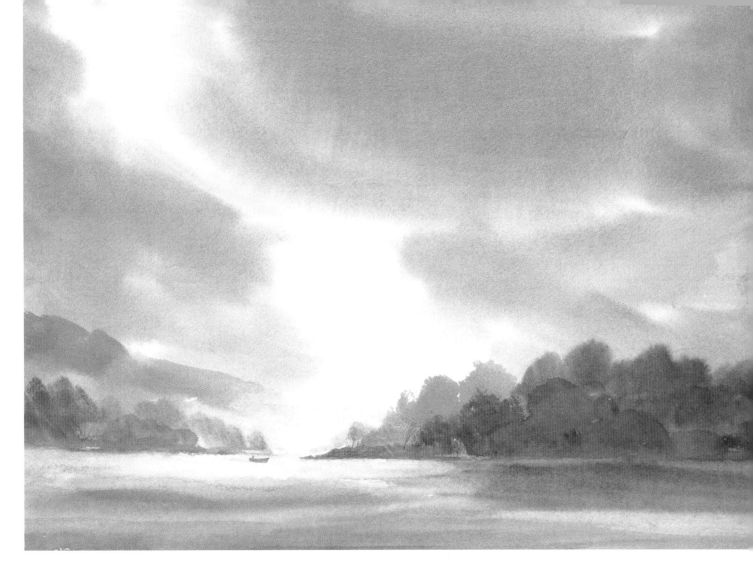

painting, even if the sky takes up nine-tenths of the whole painting area.

Never forget that the object of design is to keep the viewer's interest within the painting, so always avoid an empty sky. Not only is it boring but it lacks movement, fails to create any sense of space and doesn't even keep the eye within the picture – all good reasons for applying the principle of gradation.

Perhaps I ought also to mention perspective, of which there are two kinds. First, there is linear perspective, which basically means that things get smaller as they are further away, which applies as much to clouds as to anything else – something many students tend to forget. Cumulus clouds on the horizon are only a fraction of the size of those above your head – almost the scale of a postage stamp to a front door! Look at the sky and you'll see what I mean. Then there is aerial perspective: how things appear paler, cooler and flatter the

Design plays an important part in this rather woody picture. The eye is taken into the scene by the light area of sky, which leads to the main object of interest, the tiny boat. Note how the right-hand bank also points to this area – another useful design ploy!

further away they are. This again must be applied to skies. Distant hills against a horizon may be almost pale blue, as opposed to the warm, rich colour of foreground objects.

Finally, never forget that your role as an artist is to entertain, so the worst thing you can do is to bore your viewers. You must provide them with excitement and stimulation, to the very best of your ability – but do remember to enjoy yourself while you're doing it!

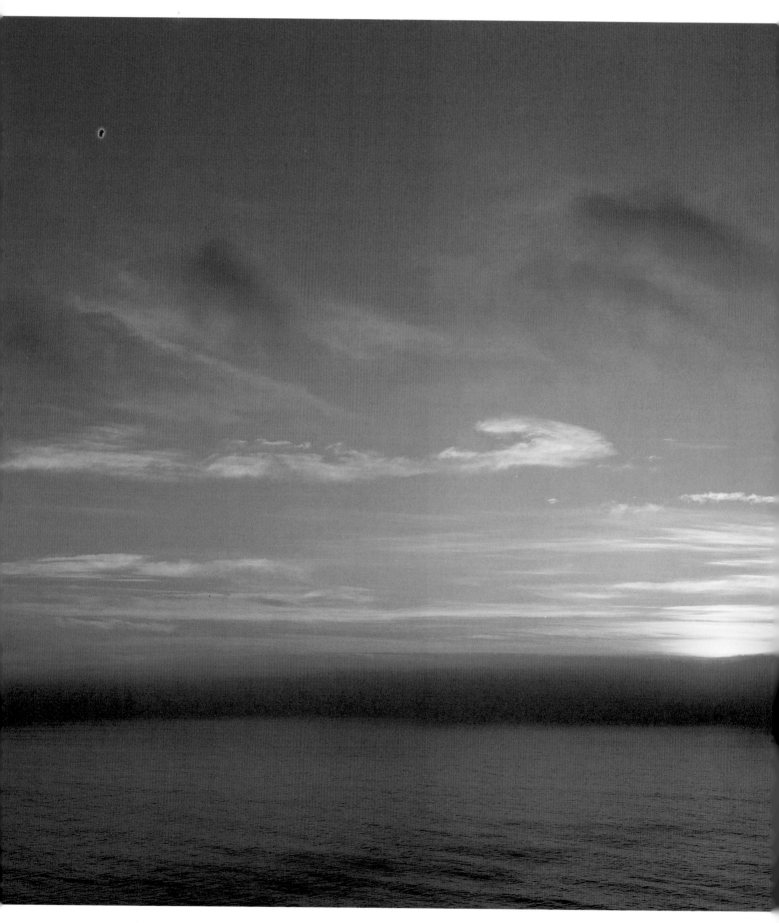

Using Your Camera

I know that a lot of artists condemn the use of photography in connection with their painting, but photographs can be a good source of reference for different cloud types. After all, weather conditions change so fast that it's not always possible to paint them outdoors, whereas they can be captured in seconds with the use of a camera. Don't think for a moment that I'm recommending this as an easy option. The more experience you get painting outside on site, the more skilful you will become in using all reference sources, including photographs. You must, of course, avoid using photography as a crutch, thinking that it can spare you taking the trouble to observe and draw carefully. In other words, use the camera as a servant, never letting it become a master. I usually keep a camera in my car and use it to capture any exciting cloud formations that I see – although annoyingly, of course, the best of these appear when I've left the camera at home! In talking about photography, we need to divide the

Here Doug Fontaine has caught the setting sun as it disappears below the horizon, lighting up the cirrostratus from below as it goes. The small cumulus clouds here are shadowed at the top, rather than the bottom, for the same reason. Photography is the perfect art form for capturing fleeting moments such as these. The resulting photographs can then be put to good use in the studio at a later date.

This is an example of how your camera can be used in association with your sketchbook. I first painted this windmill as a demonstration by the side of the road in Norfolk. However, the sky was both overcast and uninteresting and the resulting watercolour sketch was disappointing. Later, using this photograph, I did a tonal sketch combining the first painting with the photograph. I felt this worked well, so went on to produce the painting opposite, which has far more vitality and sparkle.

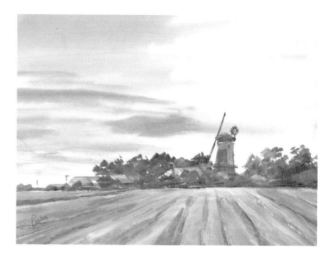

subject into colour and black and white. While colour photography seems to have taken over in popularity, there is still a place for black and white, particularly in photographing skies, where the contrast provided can be very exciting. Also, back in the studio black and white will give you more opportunity for using your imagination when you're painting.

Taking black and white films first, these are particularly sensitive to blue light. This means that they cannot differentiate between the blue of the sky and the white of the clouds. As the best way to get interesting sky photographs is to isolate the clouds from the background of the sky, the only answer is to use filters. A yellow filter will absorb its complementary colour, blue, so that very little reaches the film. This means that the blue of the sky will print somewhat darker, showing up the white clouds. Orange will darken the sky even more and a red filter will make a sky really dramatic, by absorbing nearly all the colour coming from the sky and so making it print black. Bear in mind, however, that the use of an orange or red filter will alter the recording of the foreground. For example, a red filter will make green grass almost black. Without using these filters, though, you may be disappointed, as the subtle cloud tones you saw will not register on film.

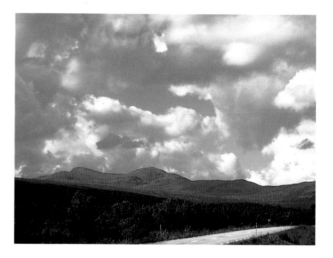

Turning to colour photography, personally I don't like to work from transparencies. Although they're better quality, the artificial light of a viewer makes them too bright. However, when preparing a book, publishers need transparencies rather than colour prints.

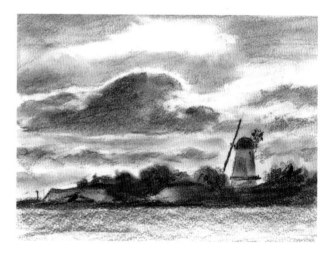

With colour transparency film, skies can be improved by under-exposure. Usually this can be achieved by up-rating the ISO reading on your camera. For example, Kodachrome 64 could be

set at 80; but don't forget to put it back to the correct reading when you have finished with skies! Do not, however, under-expose colour negative film (used for making colour prints), as the resulting prints will look washed out. A polarizing filter is a good way of enhancing skies, particularly when shooting at right angles to the sun.

Polarizing filters are rotated in a circular mount in front of the lens, so it is simple when focusing with an SLR camera to revolve the filter until the sky appears at its darkest. With a range finder camera, this will have to be done by eye. Having found the correct angle, very carefully place the filter back in its mount at the same angle.

Many people keep an ultraviolet or skylight filter permanently on the lens to protect it from scratches. This is a good idea and a clear UV filter will be an asset, but some skylight filters have a faint pink tinge to penetrate haze. However, this colour will also cut out a lot of blue, so it should be removed for cloud photography.

If you're photographing clouds near the sun, there are two ways of avoiding glare. You can either use a lens hood or position the sun behind a post or building.

Finally, a word of warning regarding sunsets. Never look at the sun through the camera or leave a camera focused on infinity, pointing at the sun, for any length of time. Your camera could be ruined!

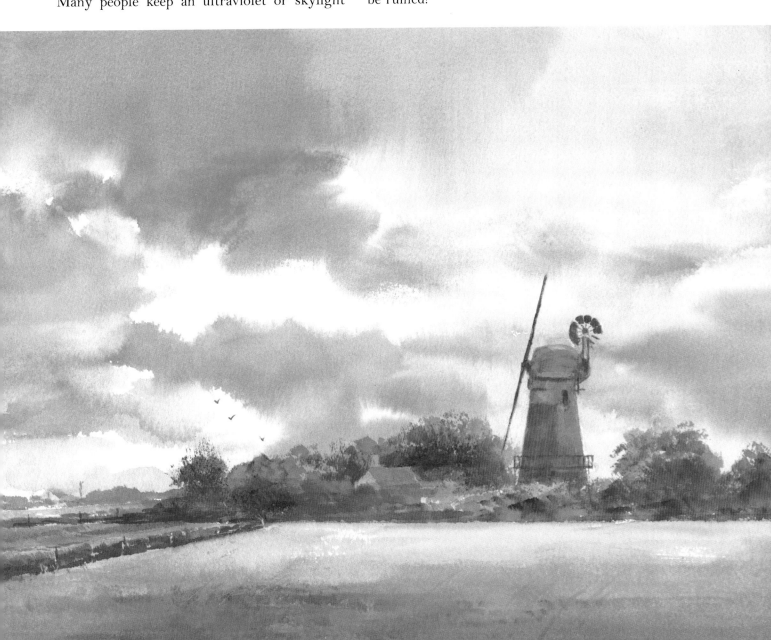

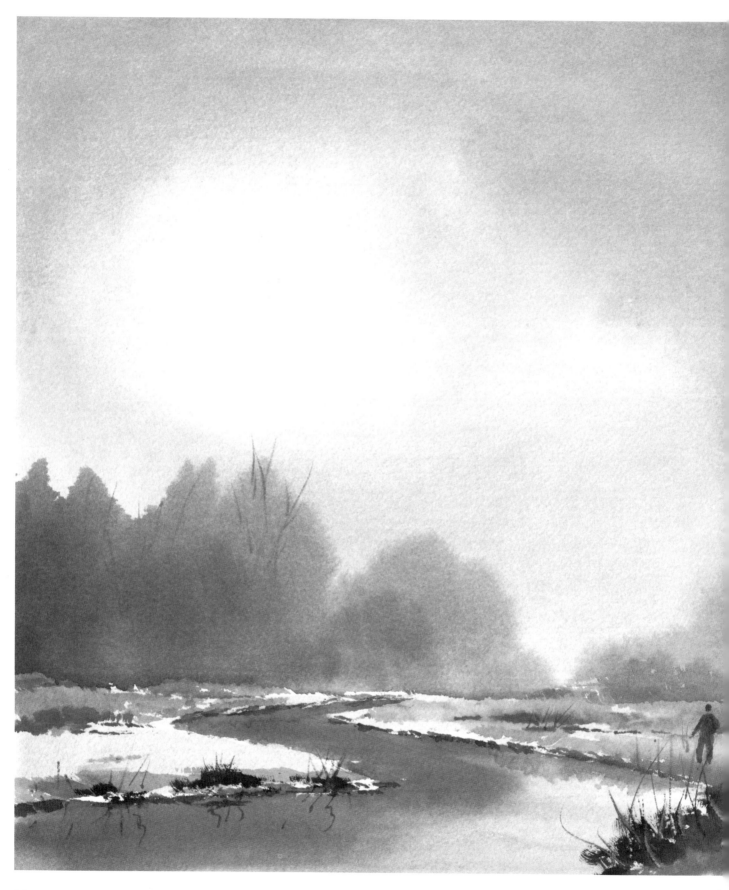

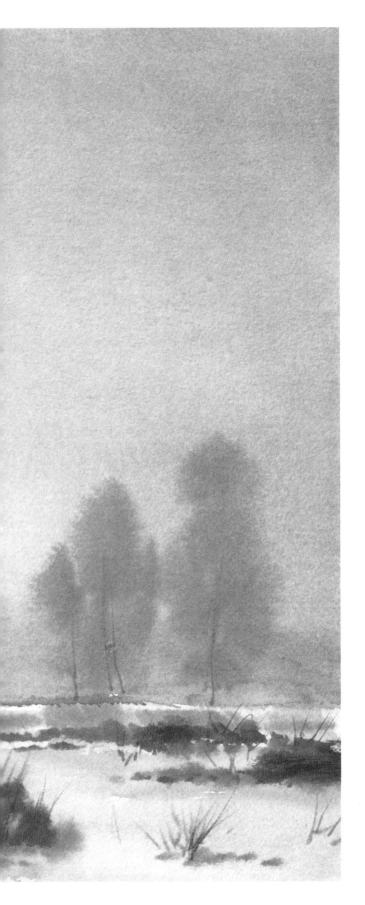

Special Effects

Watercolour lends itself to ethereal weather effects such as mist, fog and subtle light conditions, and here I've tried to show some effects which you might like to try. It can be great fun to experiment, but don't expect to achieve perfection at the first attempt. This is an ideal way to reuse your discarded paintings. Try too on various makes and surfaces, as they all respond differently. My own favourite, Bockingford, is very forgiving and responsive to, for instance, the removal of paint with a hog's hair brush to achieve streaks of light on water, while some other papers are more reluctant to give up their paint.

There is no weather effect that, with ingenuity and practice, cannot be portrayed.

This is an attempt to convey the damp misty atmosphere of an early morning in November. The sun was making a brave attempt to break through the moisture-laden sky. This is one of the few paintings on which I have used masking fluid – I don't really like it, but sometimes it does achieve a better effect. After painting the fluid over the sun and allowing it to dry, I washed over the whole sky area with a mixture of raw sienna and lemon yellow. While this was still very damp, I circled the sun with a mixture containing a little burnt sienna, ultramarine and alizarin crimson, strengthening the mix as I moved over to the right. Although I feel that this is a very worthwhile effect, to attempt it can be a bit tricky, so you have to expect one or two failures. Immediately after the sky was completed, I made up a much stronger mixture of the same colour and used this to drop in the trees. Again, the timing and water content are of vital importance. The rest of the picture was completed in harmonious colours, keeping everything very simple. The last thing of all was to remove the masking fluid, having made sure that the sky was completely dry.

In this picture of Mount Hood in Oregon, my initial aim was to portray the ground mist around the base of the trees. For this I used a strong mix to put in the profile of the trees, adding much more water as I moved down. Back in the studio, I decided to add snow as an experiment, using an old toothbrush and opaque white gouache. The spatter effect comes from rubbing the paint-laden toothbrush with the handle of my rigger. I must admit that I began with some trepidation, but I feel that the result is quite pleasing. The mountain is simply virgin paper, while the foreground snow has been washed over to echo the sky.

It was the intensity of light on the water that attracted me here. The effect was quite dazzling, as the rest of the scene was rather overcast. The sky itself was fairly complex, with lots of varying shades of warm colour. The main problem was to get the sparkling effect. Taking a deep breath before starting, the method I used was, with my hake and very wet paint, to move the brush very quickly and extremely lightly across the page. If this can be done with one stroke, so much the better. The colour just touches the high points in the paper surface and leaves the indents paint-free. It is probably wise to practise this technique on a spare piece of paper first! I waited until this area was properly dry before putting in the foreground colour.

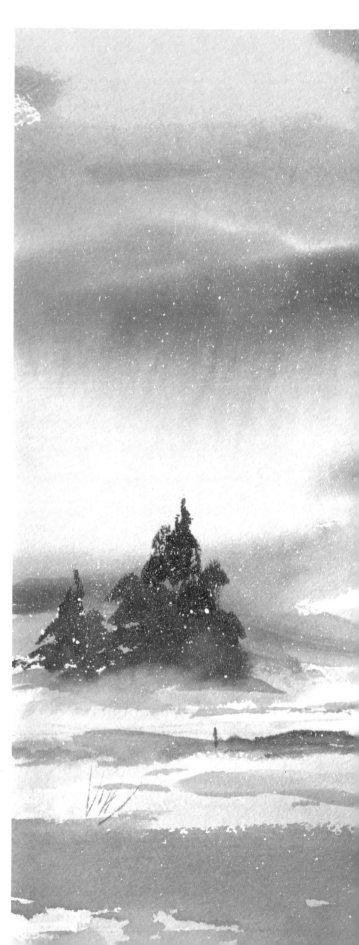

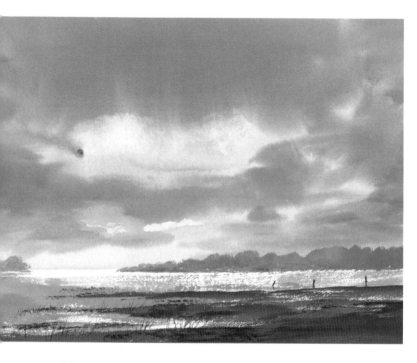

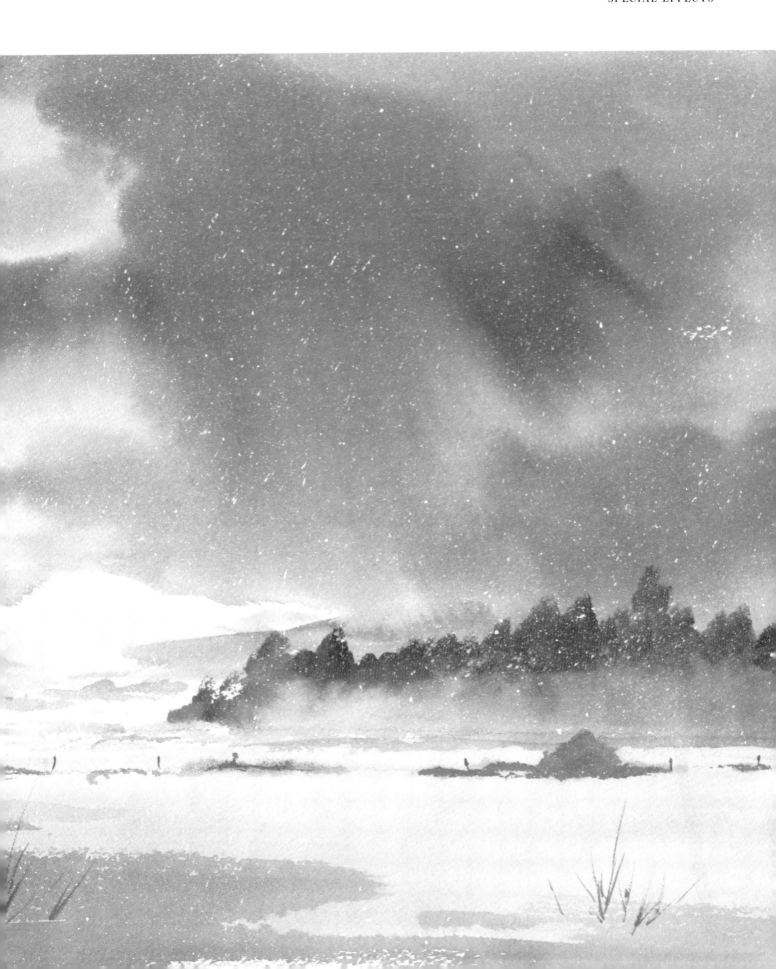

I'm frequently asked when teaching students about basic skies how to get the effect of rays of light coming from beneath a cloud. The answer is quite simple. You don't use paint but an eraser, once the painting is dry. Caution and gentleness are the key words. There are three different erasers you can try: ink erasers, which are rather harsh; ordinary pencil erasers, which are softer; and softer still are the putty erasers. Try experimenting with all three on a discarded painting. The make of paper makes a difference too. For instance, Bockingford responds quite differently from Arches. Be discreet with this technique – understatement is best here.

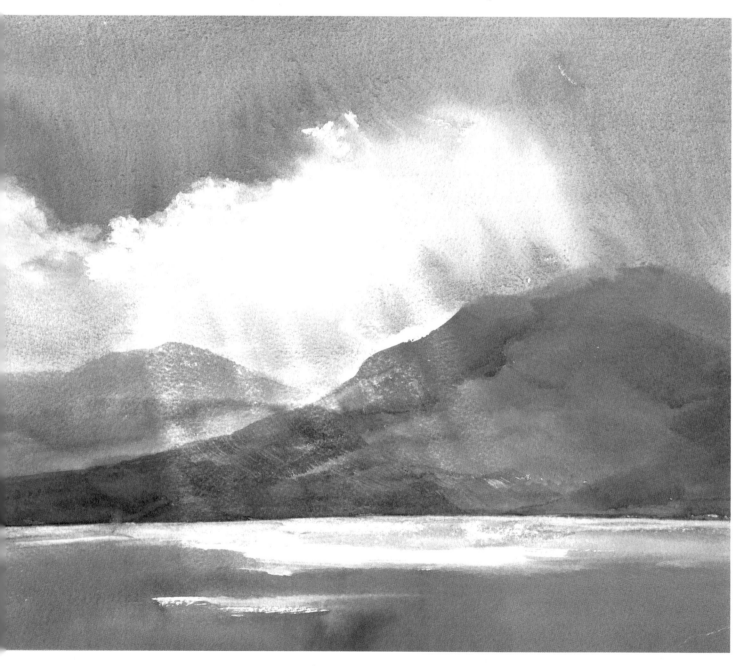

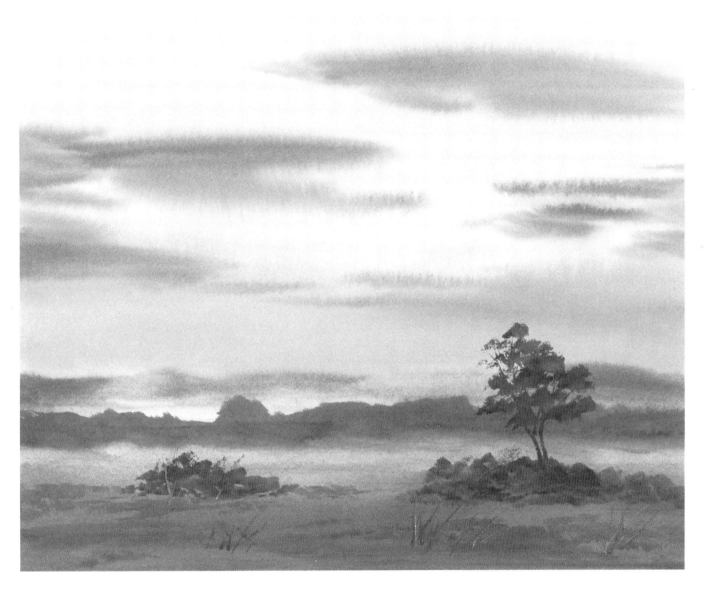

This was one of those magical mornings – a morning to be out on one's own at five a.m., watching the mist rise from the ground as dawn colours the sky above. Stillness pervades the atmosphere. I've tried to convey the various layers of mist as they recede into the background. Starting at the far horizon, the distant hills were put in while the sky was still damp. The hills were then diluted at the base. I then waited about thirty seconds before painting in the profile of the next row of trees. The colour for these was again diluted at the base. Even in a gentle, misty scene, one needs something sharp and crisp on which to focus the eye. In this case, the tree also acts as a link between sky and landscape.

Photographs as a Source

In this chapter I've gathered together some photographs which I hope you'll find useful as reference material. There's no way that you could copy these precisely and in any case you wouldn't want to. However, they may be a good starting point for some experiments with skies, or even a source of inspiration.

There's one technicality which I should explain here. You'll notice that many of the landscapes underneath the skies are very dark. This is because the photographers have had to under-expose the base in order to provide clarity and definition in the sky. Naturally, this isn't a problem the artist painting on site has to contend with – perhaps this is why the best paintings are still those done *en plein air*. As you look through these pages, you'll see that most of the photographs show a good use of cloud types. Perhaps cirrus on one side, with cumulus or cumulonimbus on the other. However, I think you'll agree that they are all stimulating to the imagination. I haven't included any monochrome skies, either clear blue or overcast.

One of the useful aspects of these photographs is that they allow you to see the natural design of a sky which, although it may be changing constantly, is always there. Perhaps once you've seen it captured by the camera, it will be easier to see when you're looking at an actual sky. For example, often when I've been out driving in the car I've noticed a wonderful build-up of cumulus cloud,

Evening drama is the phrase that comes to mind here in this rather threatening cloud formation. Having sunk below the horizon, the sun still lights the clouds with an uneasy orange glow.

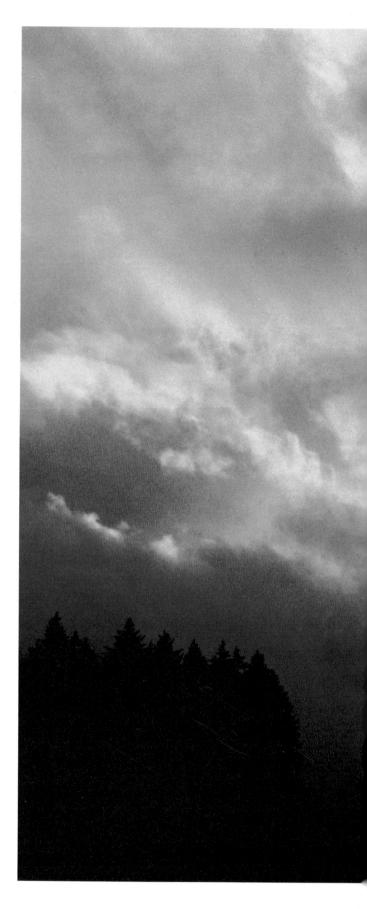

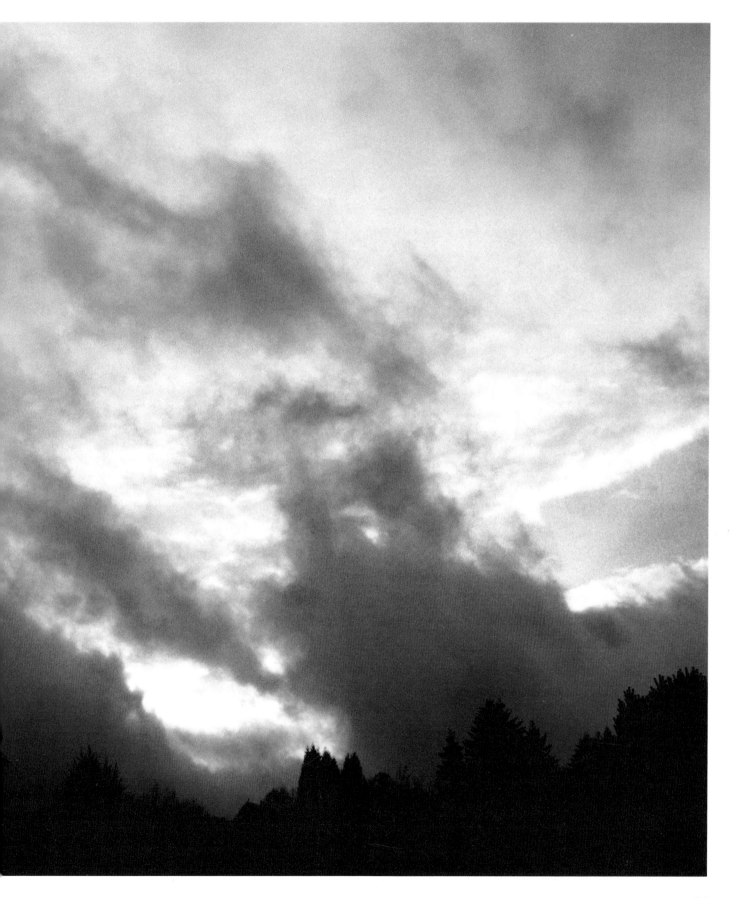

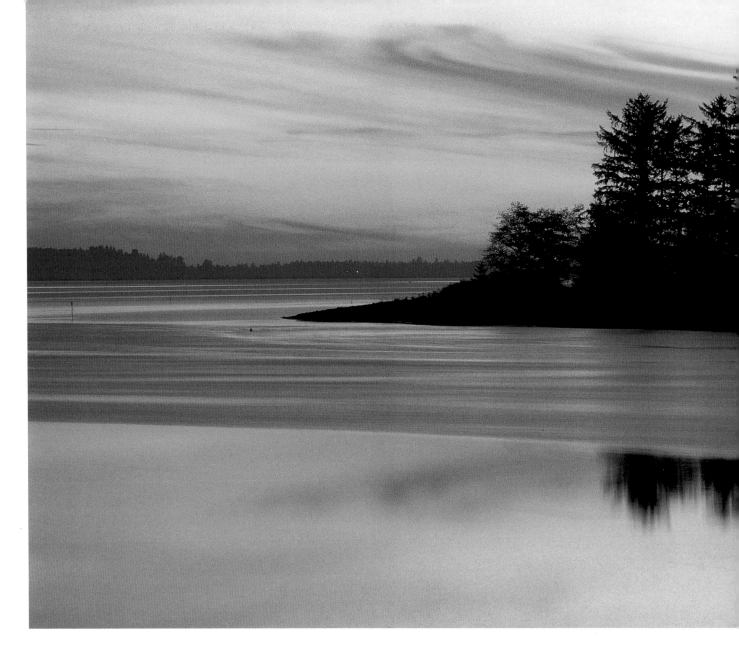

Here we have a warm evening sky with delicate streaks of cirrus adding to the tranquillity of the scene. The crisp vertical trees emphasize, and contrast with, the soft horizontal composition of the sky. Notice too the reflections in the calm water of the foreground. Think about the colour change from the top to the bottom of the sky as well. (*D. Fontaine*)

similar to that on page 80, and it simply hasn't been possible to stop and capture it, but with practice I've been able to remember the general design, which has helped when I've got back to the studio. Another thing that is easier to see in photographs is the way clouds are formed by the negative shapes behind them. There are good examples of this on pages 76 and 77.

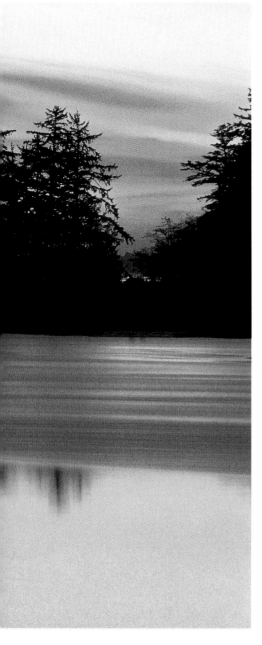

Another evening sky, this time of much more complexity, with many different cloud shapes. There are altocumulus and altostratus, together with some delicate cirrus, all combining to create an interesting, chaotic sky. Notice the lost and found edges of the horizon, which add a sense of variety and drama to the scene. (*D. Fontaine*)

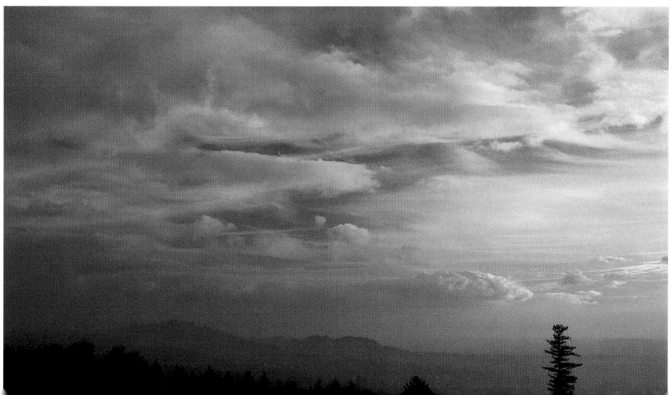

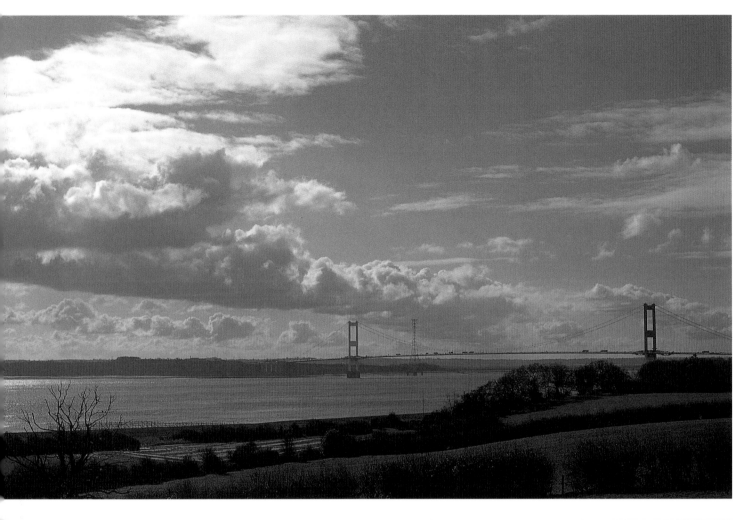

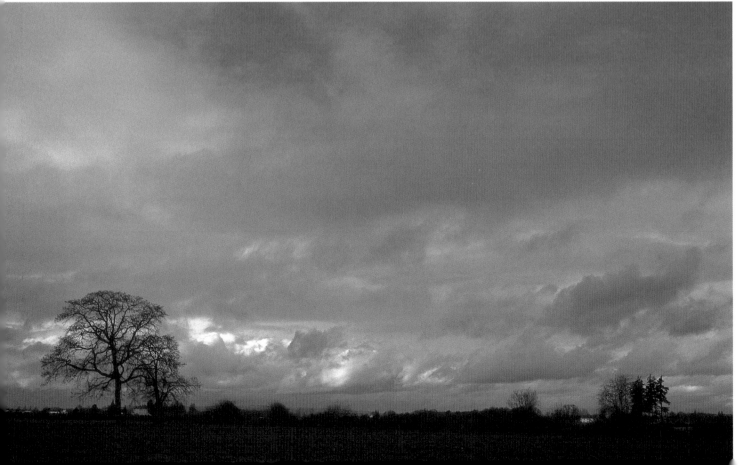

What immediately attracted me to this photograph (opposite, above) was the wonderful sweep of the S-shaped design, giving an opportunity to attempt to capture the scene feeling in a painting. One way would be to echo the flow in the landscape.

The strong design element (opposite, below) here is the dominant cloud on the right, being balanced by the tree on the left. It's obviously a windy day, with lots of movement in the cumulonimbus cloud formation. A few wind-tossed birds would add to the atmosphere. (*D. Fontaine*)

There is a tremendous variety of cloud types here (right), from the high cirrus to the nimbus piling up near the horizon, giving a feeling of space and depth. There would be plenty of opportunity for experimenting with colour in the cloud.

The main feature below is the strong negative shape, which gives an immediate lead into the design of the scene. If you were taking this photograph as a source for a painting, you would have to use your skill and imagination to produce a foreground to complement the pattern of the sky.

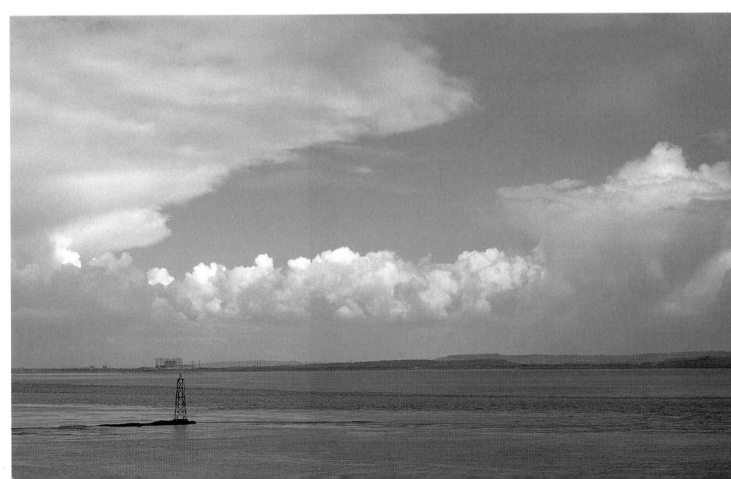

There's almost a confusion of clouds here, so probably
the best idea would be to simplify the cloud shapes.
Think too about the differences in size as the clouds
recede towards the horizon. There is plenty of
counterchange here as well: you can see it between the
dark and light clouds, and between the cloud and the
blue sky. Care should be taken to balance the weights of
both the clouds and the foreground scene. (**D.** *Fontaine*)

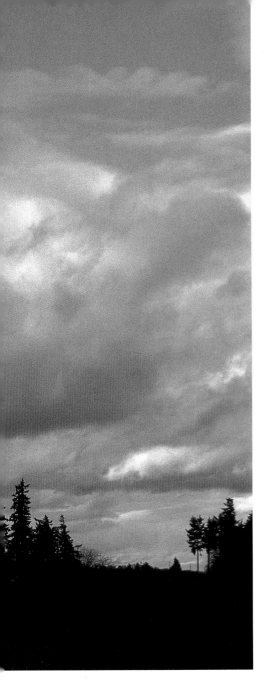

No rainbow is going to wait while you get out your paints, but it may well be possible to capture it on film. You're then confronted with the challenge of reproducing these colours in paint. It's possibly slightly easier in pastel or oil, but more exciting in watercolour. One constant feature which you can rely on, though, is that the colours are always in exactly the same order.

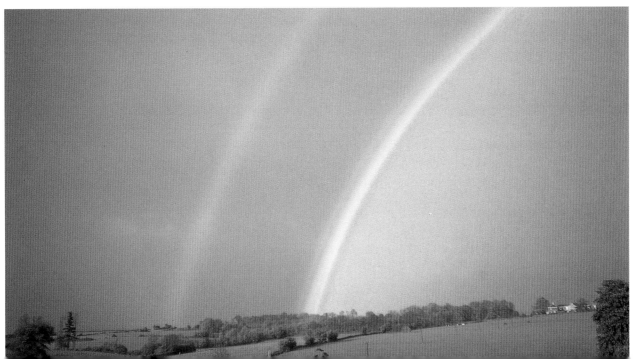

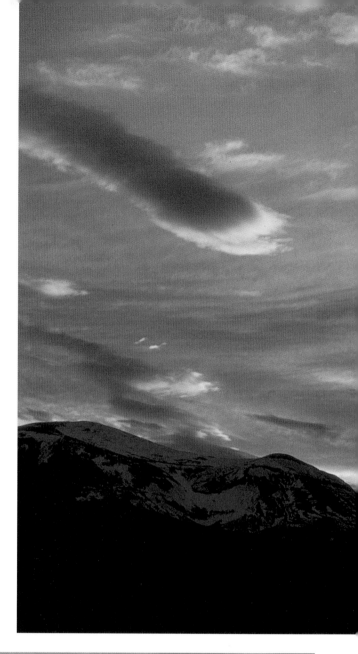

There is an incredible amount of drama in this scene (below), with vast contrasts of both colour and tone. Use these elements to design your own sky, remembering that in any painting it is better to have the main feature – in this case, the sun – off centre. If you're using water as a foreground, make sure that the sky colours are repeated in it.

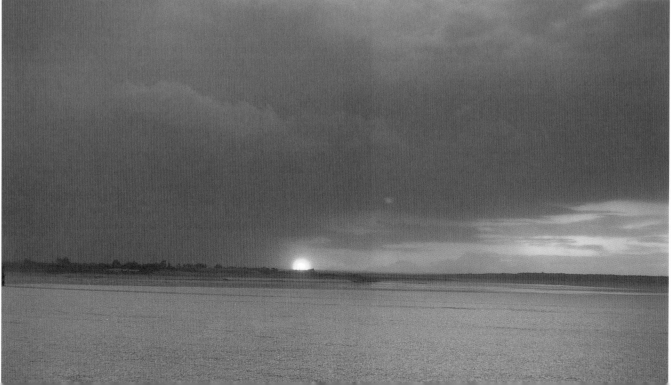

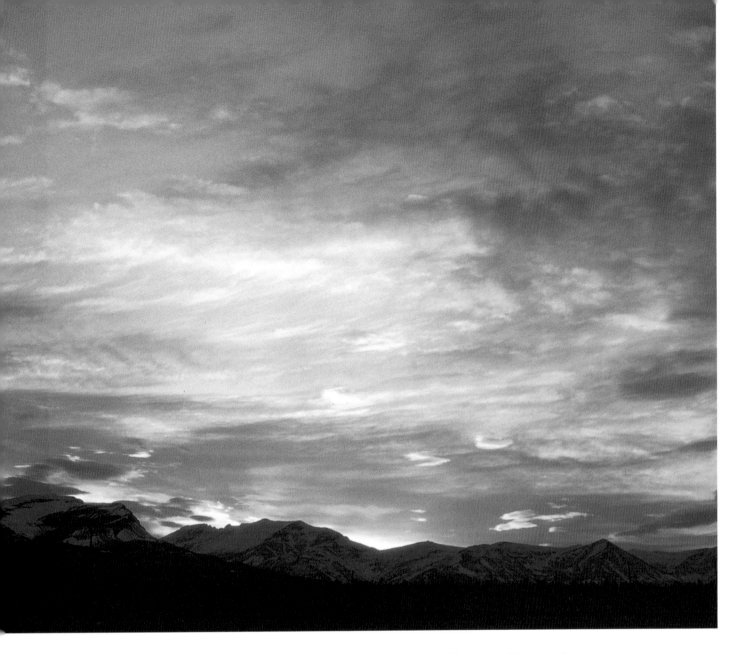

The main problem with this type of scene is to capture the drama without lapsing into gaudiness. Subtlety is the keyword here, relying on contrast of tone rather than brightness of colour. Remember too that a landscape would not usually be as dark as this.

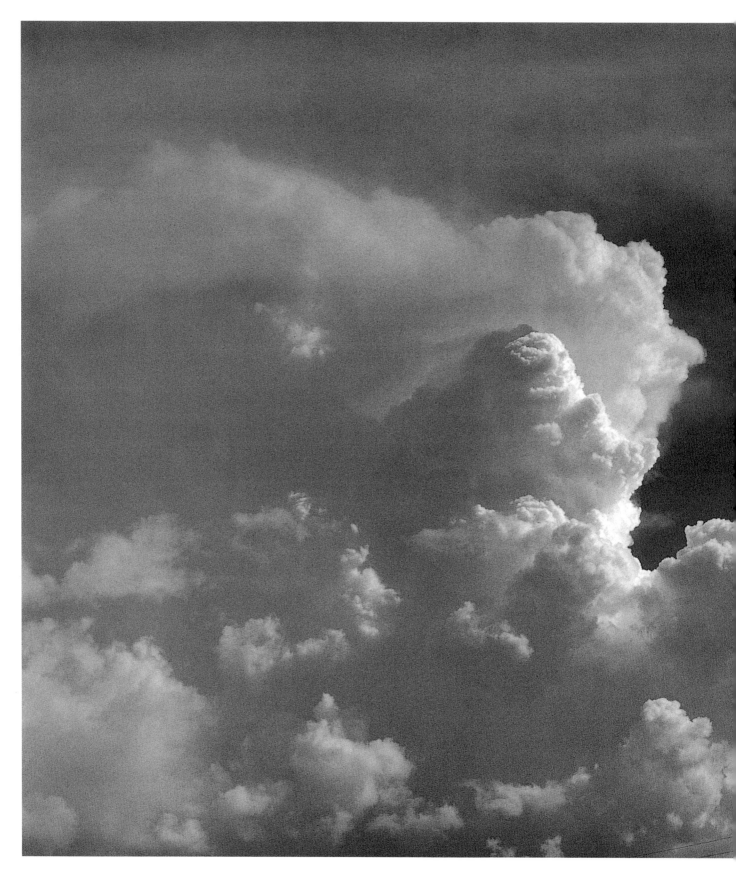

This is a good example of cumulus cloud, with its cauliflower shapes building up from a flatter base. You'll often see these on a breezy summer day, when the fluffy whiteness provides a wonderful contrast with the blue sky behind. I always feel that they give artists an opportunity to get strong pattern into their painting.

This is another evening sky over the Severn Bridge, which is visible from my home. Each time I cross the bridge, I see something to excite me, no matter what the weather condition. In this chaotic sky there are rich contrasts between dark and light, together with a good variety of cloud size.

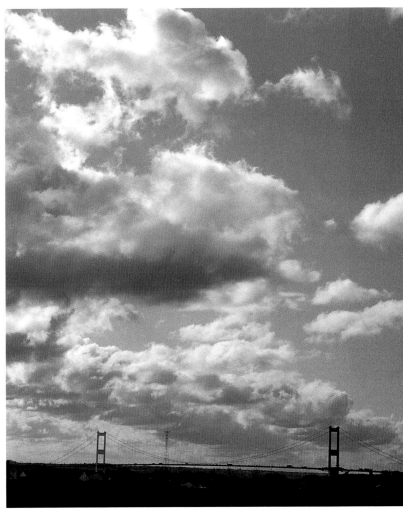

Both photographs on these pages are of altocumulus skies, but taken at different times of day. In this early morning scene (below), the low sun is providing back-lighting to the clouds from the bottom right of the picture. It's a good exercise to look at these photographs and decide where the light is coming from. Notice here how the sky is dominated by the large, mainly grey cloud in the top right.

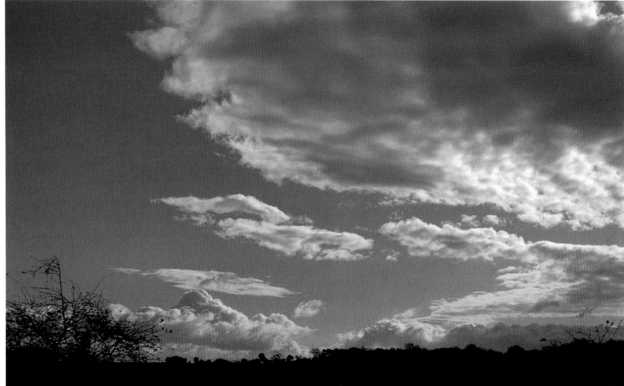

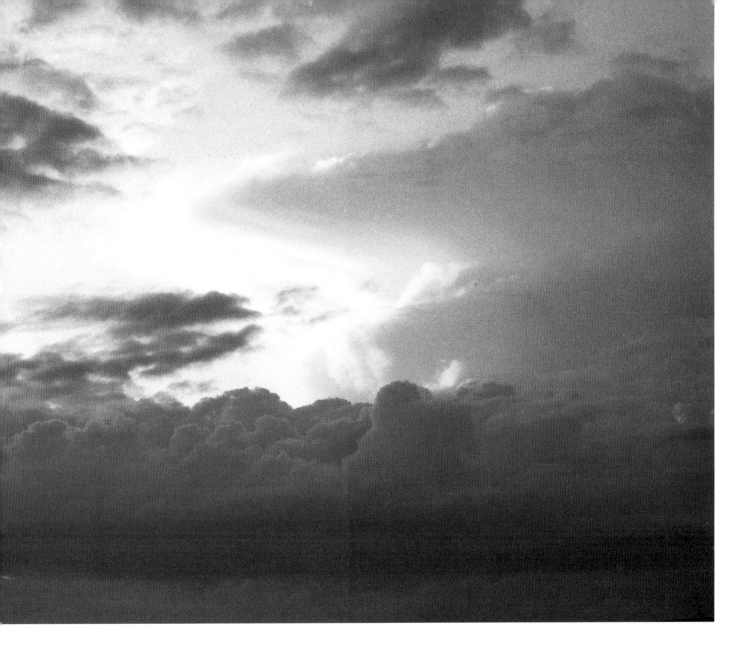

Here the sun has disappeared behind the piled-up stratocumulus, giving the effect of stage lighting to the sky above. The three drifting clouds would be improved in a painting by varying their relative sizes. There is good opportunity here for the use of delicate, subtle colour.

Reach for a Sky

Each watercolour sky you paint is a product of several factors. These include the water content, the angle of your board, your degree of skill and, although perhaps I shouldn't say this, an element of luck. All of these combine to ensure that it's totally impossible to copy a sky. Whether it's a success or a failure, each one is unique. If you're working in oil or pastel, it's not so much of a lottery; you can be far more structured and systematic in your approach. I can't help feeling, though, that there isn't quite the excitement there is in watercolour, but perhaps I'm biased.

The purpose of this chapter, then, is not to provide you with paintings to copy, but to start you off with ideas and inspiration. For instance, the sky on the right could look good over a Scottish grouse moor.

I hope too that the paintings on these pages will encourage you to become more adventurous and get away from 'safe' skies, which can often be flat and boring.

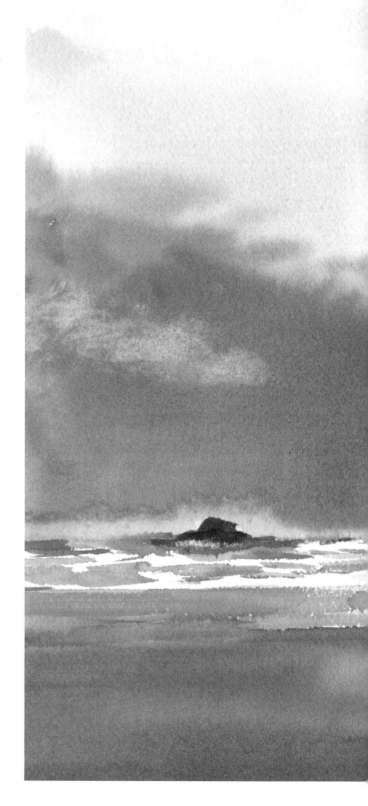

This wild sky was done on the Pacific coast of Oregon. The reflection of the sky in the wet sand gives an instant unity to the scene, and also adds to the feeling of foreboding that is due to the approaching storm. After an initial pale wash of raw sienna, I dropped in some Prussian blue to the top right. Quickly, while the initial wash was still damp, I dropped in a very rich mixture of Payne's grey and alizarin. Some of this was immediately dabbed out with tissue to create the lighter clouds in front, near the horizon. For the sea, I left plenty of white paper to convey the rollers. The small figure provides a focal point.

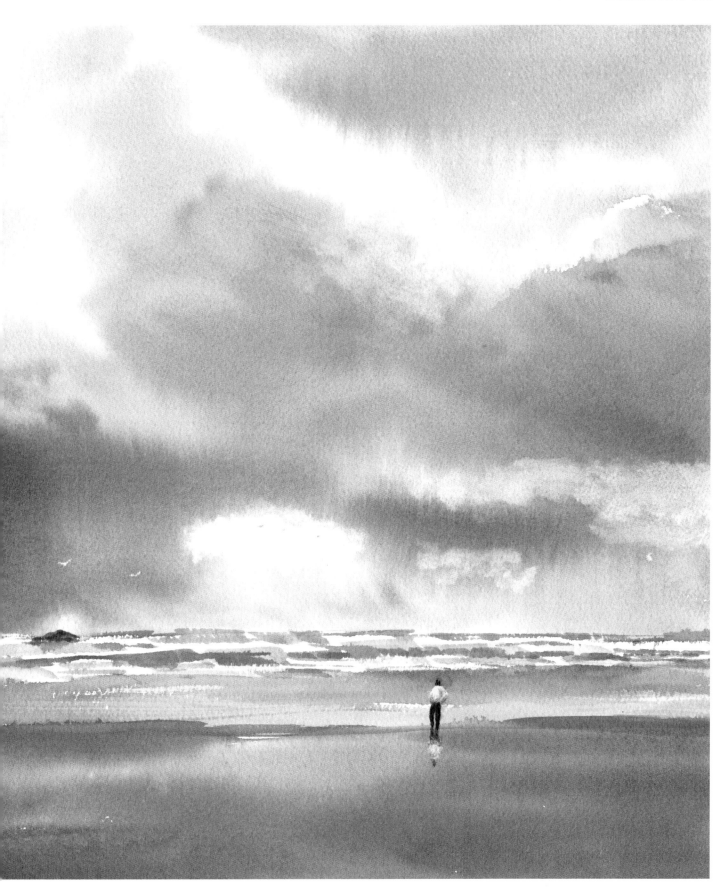

The simple gradated sky was painted using my usual very pale sienna wash, followed by a strong wash of ultramarine over the top. As I moved my brush backwards and forwards towards the horizon, I gradually took weight off the brush until it was no longer touching the paper. I then tipped the paper up to allow it to gradate. Ultramarine is one of the colours which granulates, as you see here. Personally, I like the effect. The main bush helps to link the sky to the landscape below, adding a sense of unity to the scene.

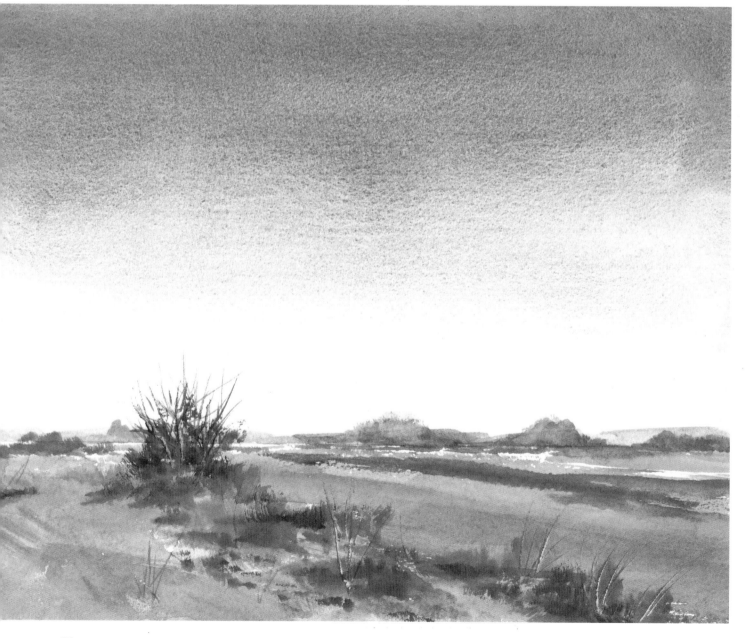

REACH FOR A SKY

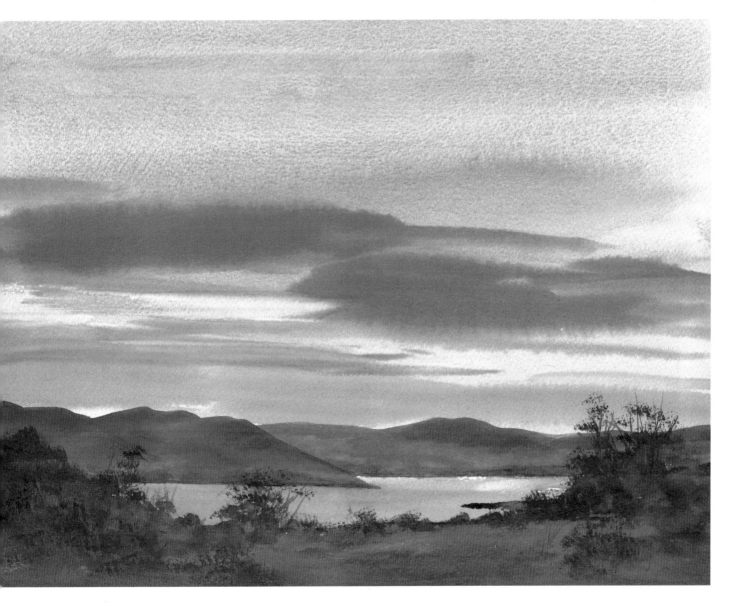

I was attracted to this peaceful evening scene by the complexity of the colourful sky in a darkening landscape. The scene required a good deal of thought and a methodical approach, as the sky depends very much on water content. It needed to be done in two stages, the first being very quickly followed by the second. After the first pale raw sienna wash, I concentrated on the variation in colour. Ultramarine at the top, followed by alizarin, lemon yellow, with more alizarin crimson added to the yellow at the horizon.

While all this was still fairly damp, I applied a stronger mixture of alizarin and Payne's grey to form the clouds. This had to be done quickly and with decision, and then left alone. I knew that if I went back and poked about at it, I would wreck it, so there's a lot of self-control in this picture too! The foreground colours echo those of the sky, providing unity and harmony.

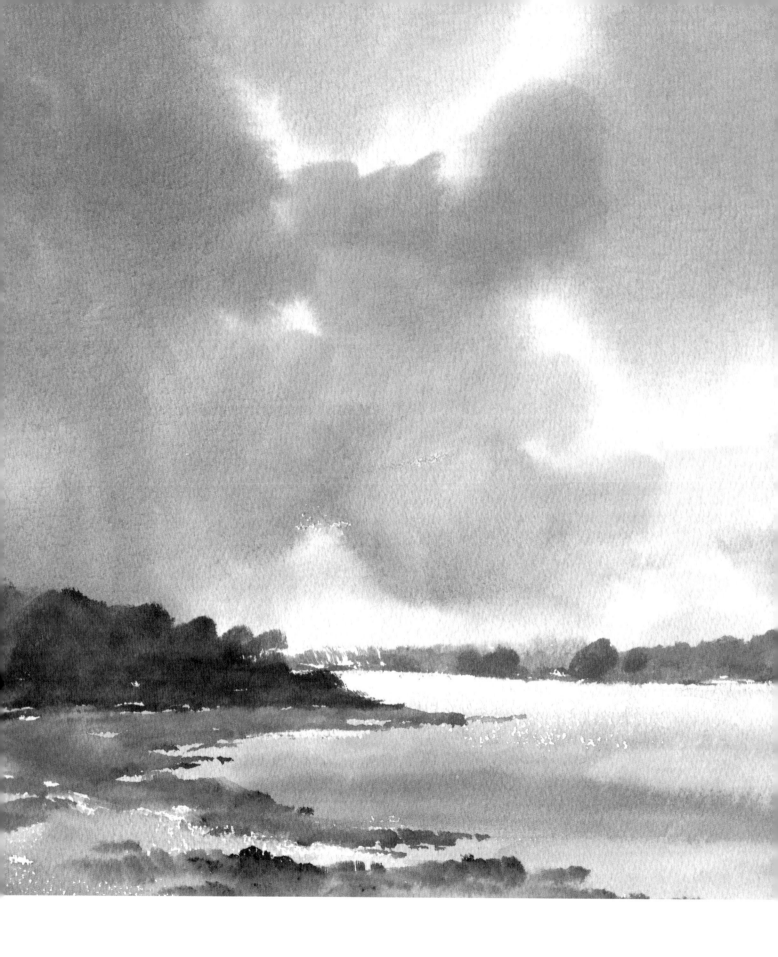

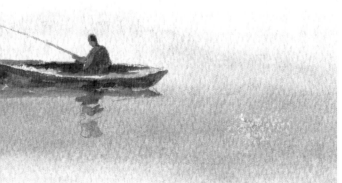

There's plenty of movement in this sky, which contrasts well with the feeling of stillness in the foreground fisherman. There is contrast too, between the cool blue and the warmer cloud colour. The sky was painted very quickly, wet into wet, to maintain the freshness. Even some of the distant trees were dropped in with strong colour before the sky was dry. Notice how I've left white paper in the distant water and echoed the sky colour in the water and foreground beach. This repetition of colour is an important factor in achieving unity in a painting.

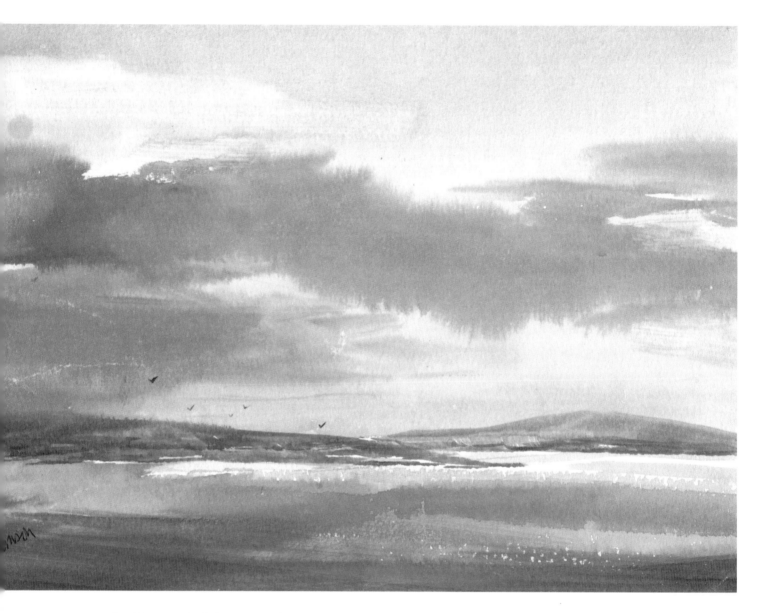

In this type of subtle evening sky, you must ignore the
main clouds until you've got the gradated sky with its
gently changing colour in place. Only then do you take
your strong, rich mixture and put it on boldly, while
the gradated wash is still damp, and then wait for it to
blend. The same colours are used in the mud of the
estuary, but applied with a drier brush for more solidity
and texture.

This complex and colourful evening sky was great fun to do. I first painted in a gradated sky, adding a mixture of lemon yellow and alizarin in the bottom right. While it was all still wet, I put in the darker clouds, quickly painting right across the sky again, using a whole arm movement (I always feel I have to stand up to do this properly). I used tissue paper to break up the clouds. You'll realize that I had to work fast to complete the whole sky before the washes dried. I then had a breathing space before completing the foreground. I enjoyed this painting and, looking back on it now, feel that I captured the atmosphere of the scene.

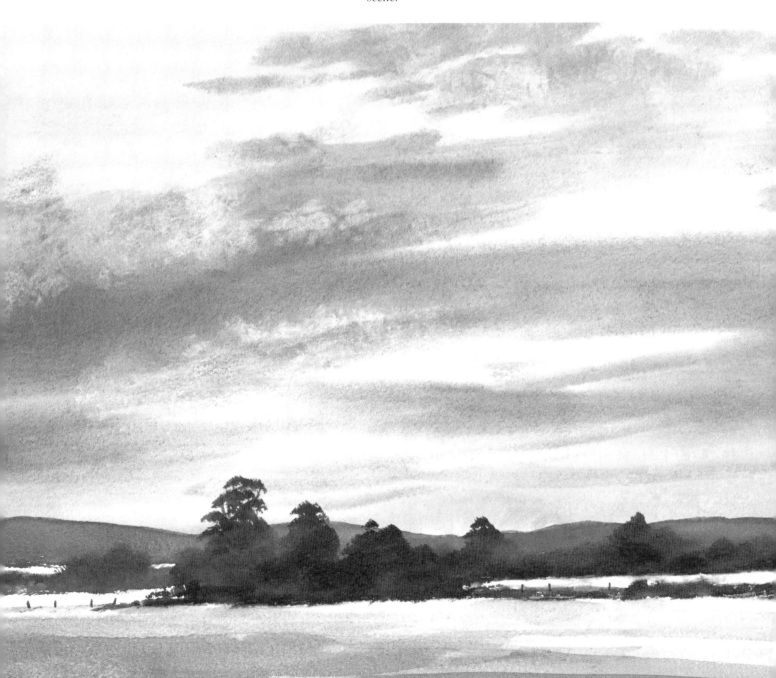

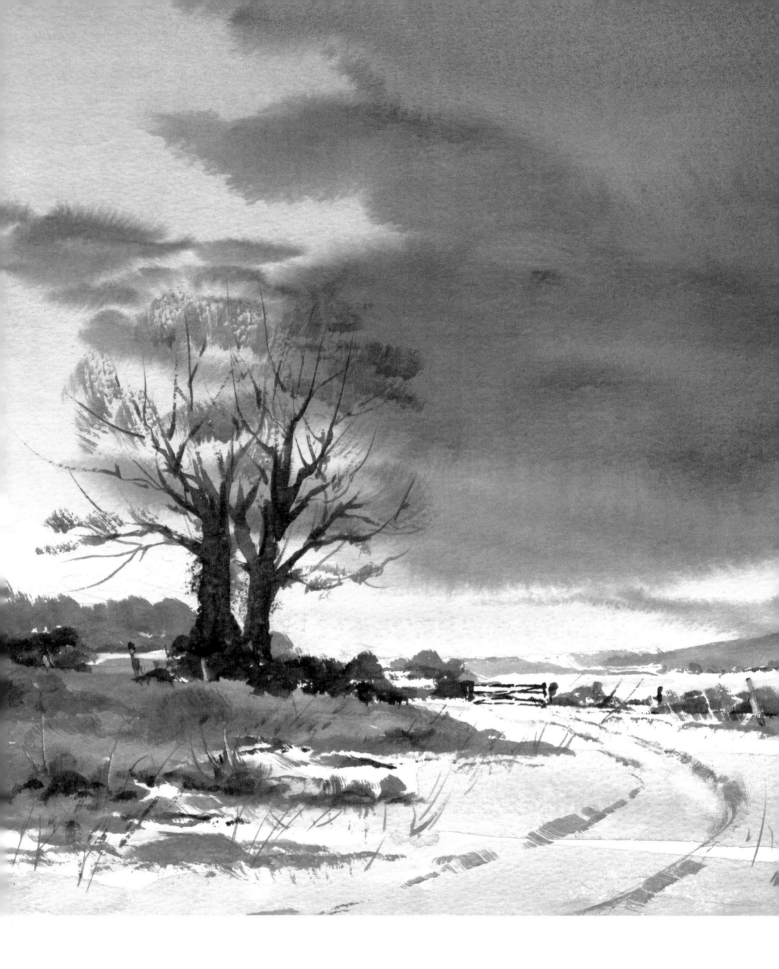

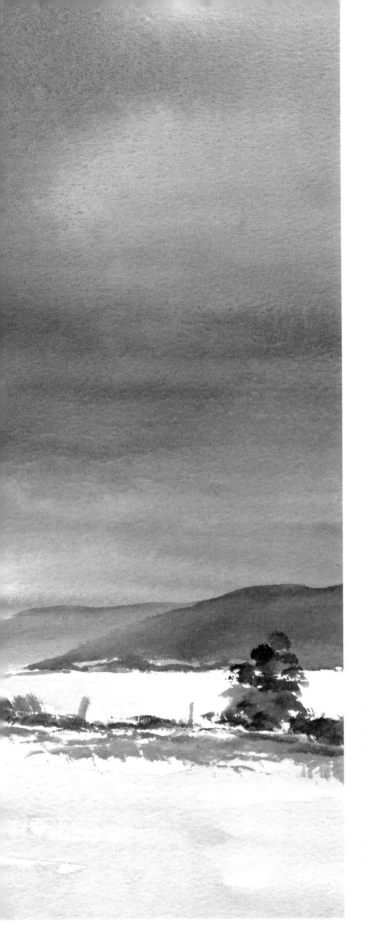

You may have noticed that I enjoy snow scenes and this one provided quite a challenge, with its threatening clouds promising yet more snow. Designwise, the eye is taken into the picture via the cart tracks to the only man-made object, the gate. The strong silhouetted trees provide a balance with the dark clouds. Notice too how these trees are placed against the lightest part of the sky to give contrast and impact. I dropped cobalt blue into the dampened sky area, and below this a wash of lemon yellow. Then, taking my courage in both hands, I threw in a strong wash of Payne's grey and alizarin. Always be aware that the rich wash will fade back, so allow for this in the strength of your mixture.

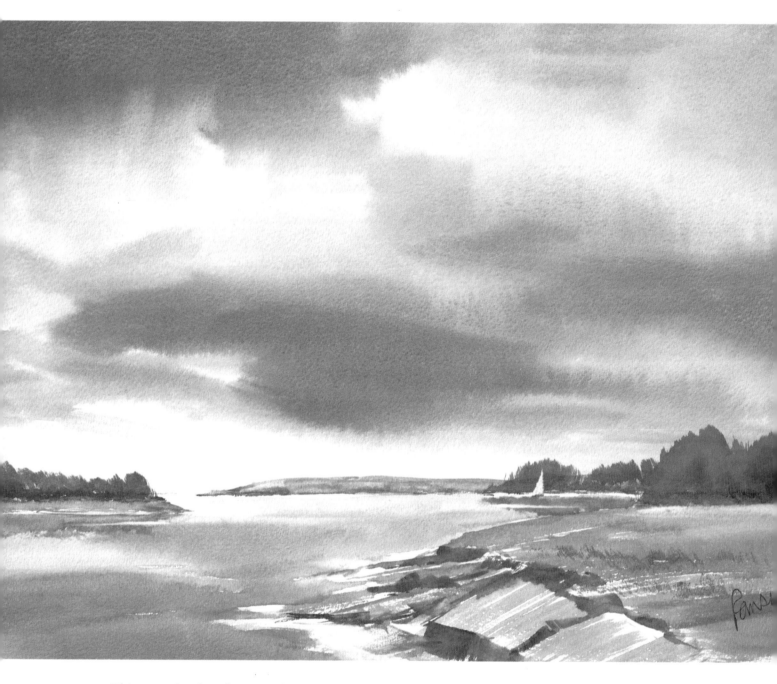

This was painted on the coast of Maine, where I've
taught annually for the last ten years. This
cumulonimbus sky was very satisfying to paint. Timing
and water content were both of the essence. To the first
raw sienna wash, I added lemon yellow near the
horizon. To warm up the cloud colour, I added burnt
umber to my alizarin and Payne's grey mix. I then used
the hake to put on this wash in varying strengths,
using the angle of the board to create movement and
gradation. You'll notice again the colour reflected in the
water and the use of the contrasting dry brush
technique, as opposed to the water and the clouds.

This painting depicts a calm, misty morning in Fort William in Scotland. I've tried to convey the atmosphere of the scene by using restricted but harmonious colours. I put in the distant hills before the sky was quite dry, which has given a soft effect, and this contrasts well with the sharp line of the jetty. Most of the painting was done using raw sienna, alizarin and ultramarine, which, used in various strengths, produced the pinky mauves throughout the painting. In a scene such as this, with most of the action taking place in one small area, you can afford to allow the rest of the picture to be calm and uncluttered, with only the tiny boat and its wake to disturb the optical silence.

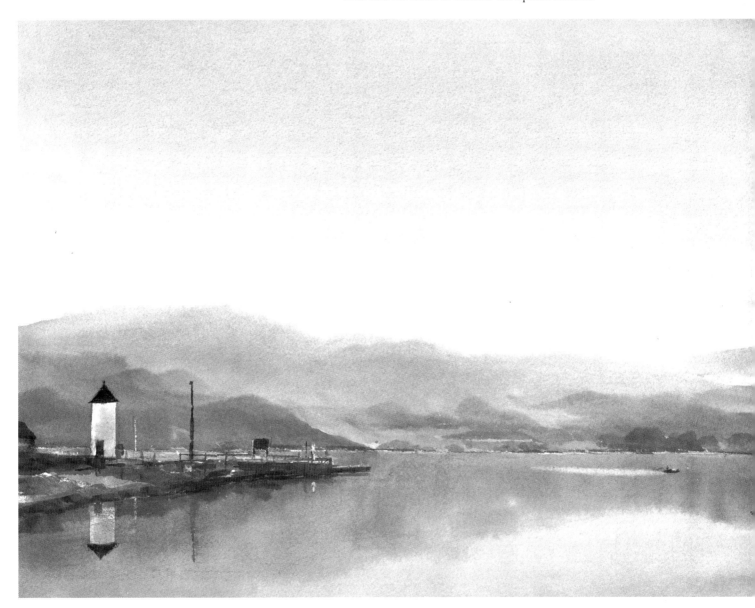

I now teach in Norway, and this is a typical Norwegian fjord scene, painted in cool evening light. The foreground foliage forms a partial frame for the distant scene and the calligraphy contrasts well with the softness of the cloud forms. Notice how the sky colour is echoed in the foreground snow. The gentle reflections in the water helped to produce this satisfying and harmonious scene. Again, it's necessary to put in all the subtle variations in the sky before the main cloud formations go in over the top in stronger colour.

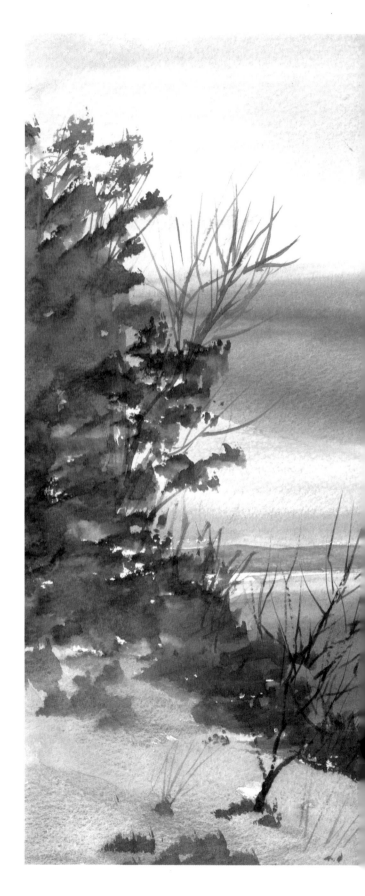

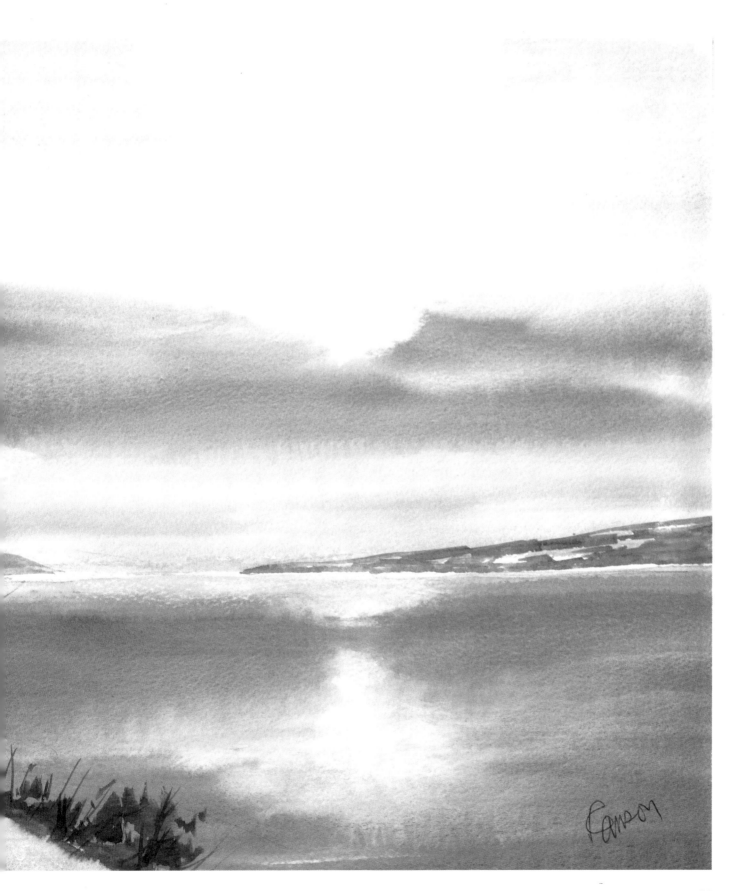

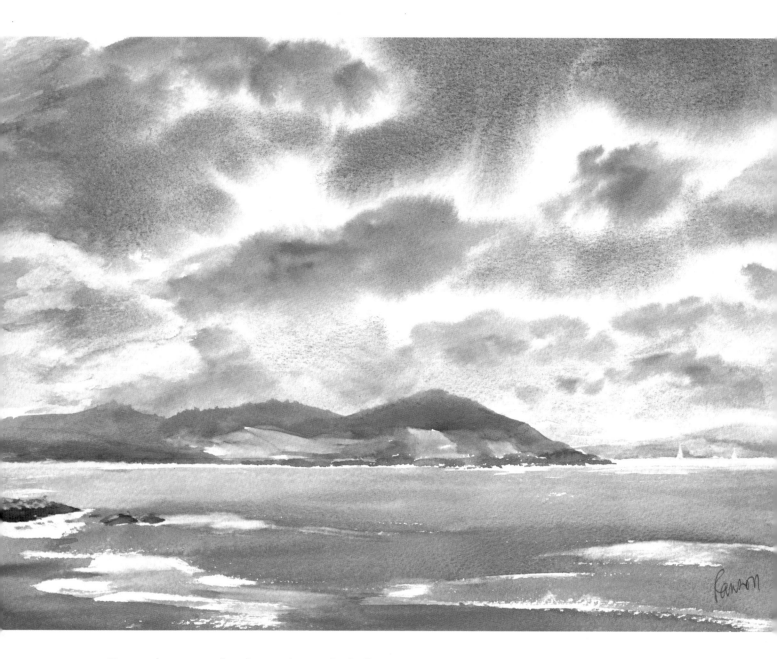

Here we have a cumulus sky on a breezy day in Devon.
I've tried to keep the whole picture warm and
harmonious by repeating the sky colour in the sea and
hillsides. The clouds are, of course, created by using the
blue as a negative shape, remembering that the clouds
should get smaller as they reach the horizon, as an aid
to perspective. Once the cloud shapes are created, the
shadows within them should be put in before the initial
all-over wash has dried. This type of sky causes ground
shadows, which create interest on both land and sea.
Notice too the use of the white paper.

This dramatic evening composition was one which I just had to try. I'm horribly aware how easy it is to end up with a scene which is gaudy and 'bitty'. I've tried to avoid this by restricting the number of colours and simplifying the cloud shapes. Unusually for me, I used masking fluid to help create the sinking sun and its reflection. Initially ignoring the clouds, I put in a gradated sky on a damp wash, using alizarin crimson, lemon yellow and cadmium orange. Only when this was completed did I put in the clouds with a strong wash of alizarin and Payne's grey. The difficulty here is to time this wash so that you get a soft edge without losing the overall shape of the cloud. Having removed the masking fluid, I used a careful wash of lemon yellow.

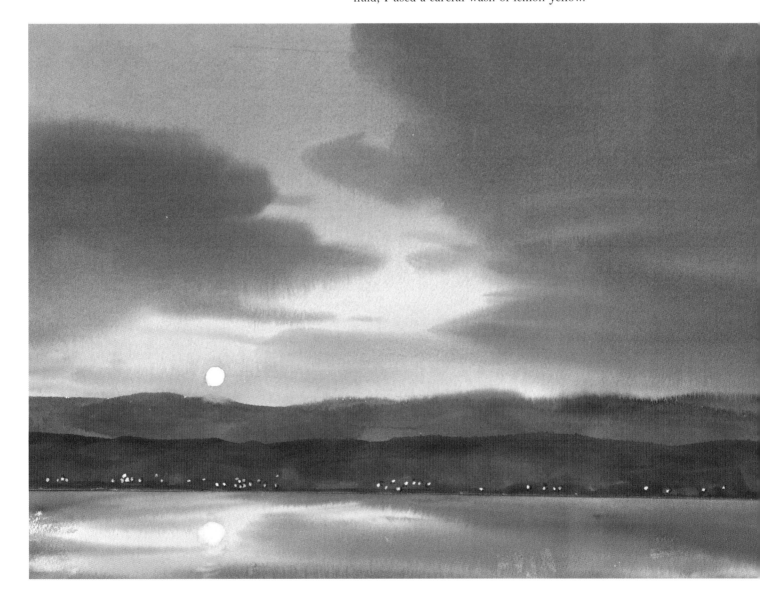

What attracted me to this sky was the challenge of having to change my thinking about sky colour. The sky seemed to be made up of pinks and mauves, and the hillside also had taken on quite a different hue. It was important here to echo the sky colour in the foreground. In this case, I allowed the initial weak wash of raw sienna to dry. I then made the mauve from a little blue mixed with light red, which I put on leaving a clear edge to form the cumulus cloud. This I continued down to the horizon. I then put in the two darker clouds in thicker paint while the wash was still wet, allowing the soft shapes to form. The clear pink of the cumulus cloud involved letting the whole sky dry, then rewetting with clear water before putting in the weak alizarin. The hillside went in next, partly wet into wet, partly hard-edged, this time using Antwerp blue. The foreground plan was put in with long strokes of the brush, being careful to introduce some of the pinks from the sky.

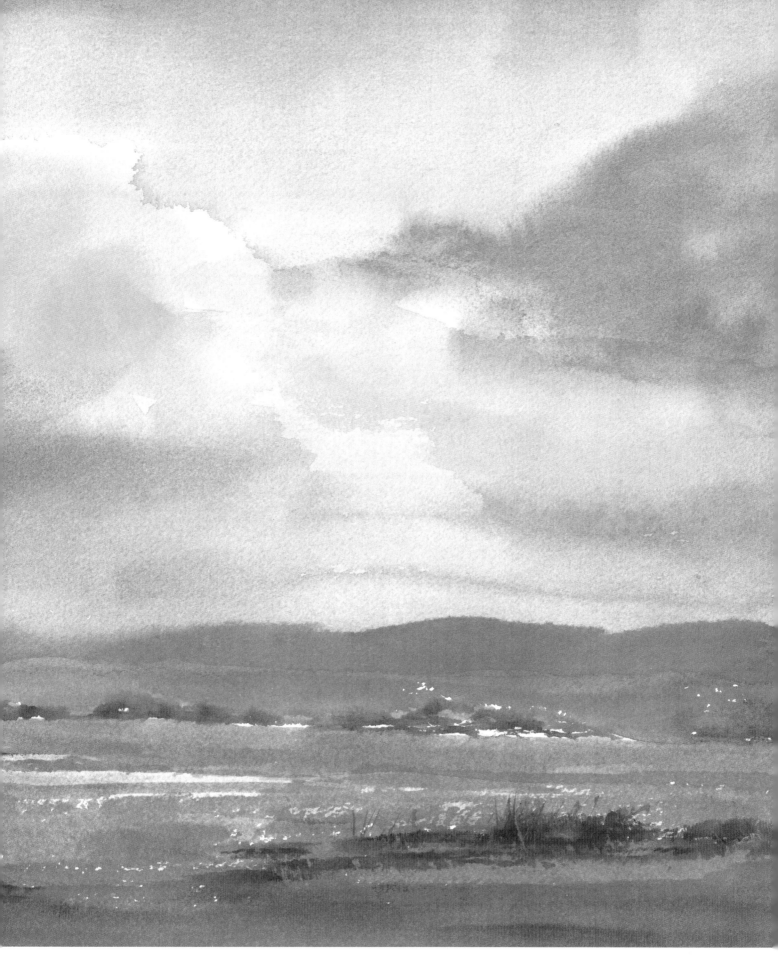

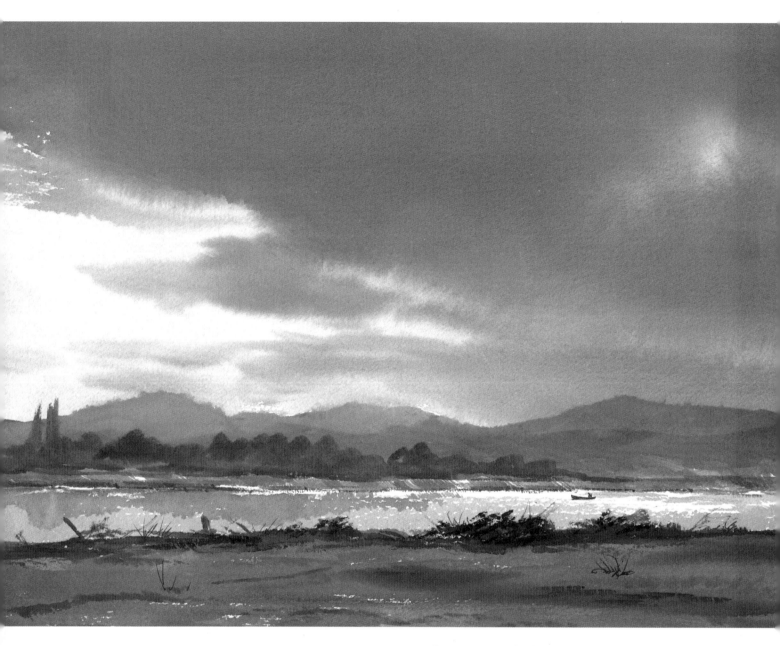

In contrast to the last page, this scene is almost
monochromatic. To make this type of sky work, it has
to be done boldly, with as few strokes as possible,
allowing the paint to 'do its own thing'. On a day like
this, the colour scheme is necessarily limited, although
I've added some reds in the foreground to create
interest and variety. The two vertical trees here are
important as a contrasting element in a mainly
horizontal composition and they also help to form the
whole picture into a unit by linking the sky and land.
When tackling this type of sky, it is a good idea to have
your board at a fairly steep angle, allowing the paint to
move.

In this bright and breezy scene the cumulonimbus clouds race across the sky. I've varied the colours in the beach from cool to warm. I feel this is very important, because in a large area of foreground it's easy to fall into the trap of monotony. You'll notice that the sea consists largely of the white paper. Thinking back to our chapter on design, you'll see that the two boys, the main object of interest, are placed at a different distance from each edge of the painting.

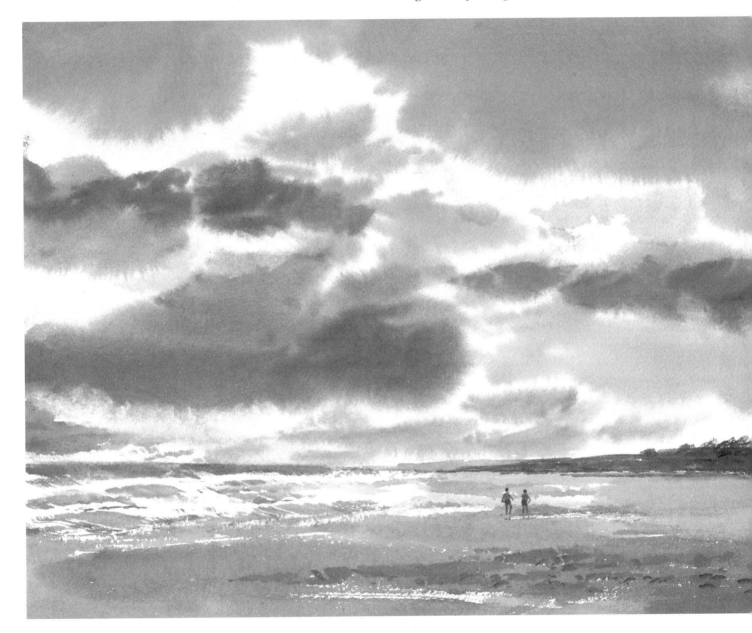

Here's a really wet cumulonimbus cloudscape. The secret of giving the impression of approaching rain is to put a strong, very rich cloud colour on to a fairly damp all-over wash. Naturally, the wetter the original wash, the faster it moves. Even in this type of sky, I like to make one cloud bigger and stronger than the rest, providing the element of dominance. You'll notice that the clouds on the horizon are tiny by comparison. The lost and found element of the horizon hills adds to the feeling of approaching rain, and was achieved by painting the hills into the sky before the latter was dry. I waited longer before I painted the harder edges on each end of the horizon. I tried to use contrasting techniques for the foreground rocks and water, leaving the white paper to do as much of the work as possible.

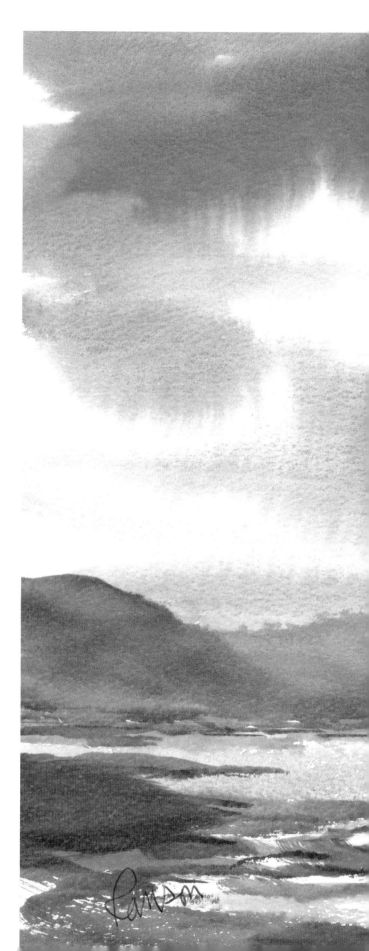

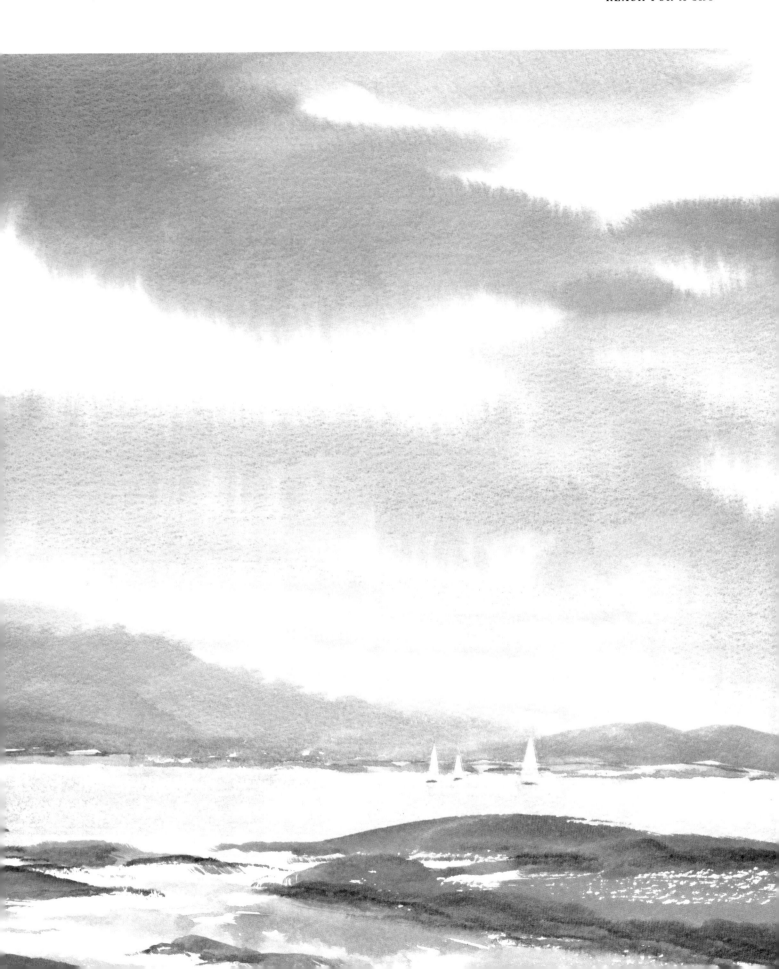

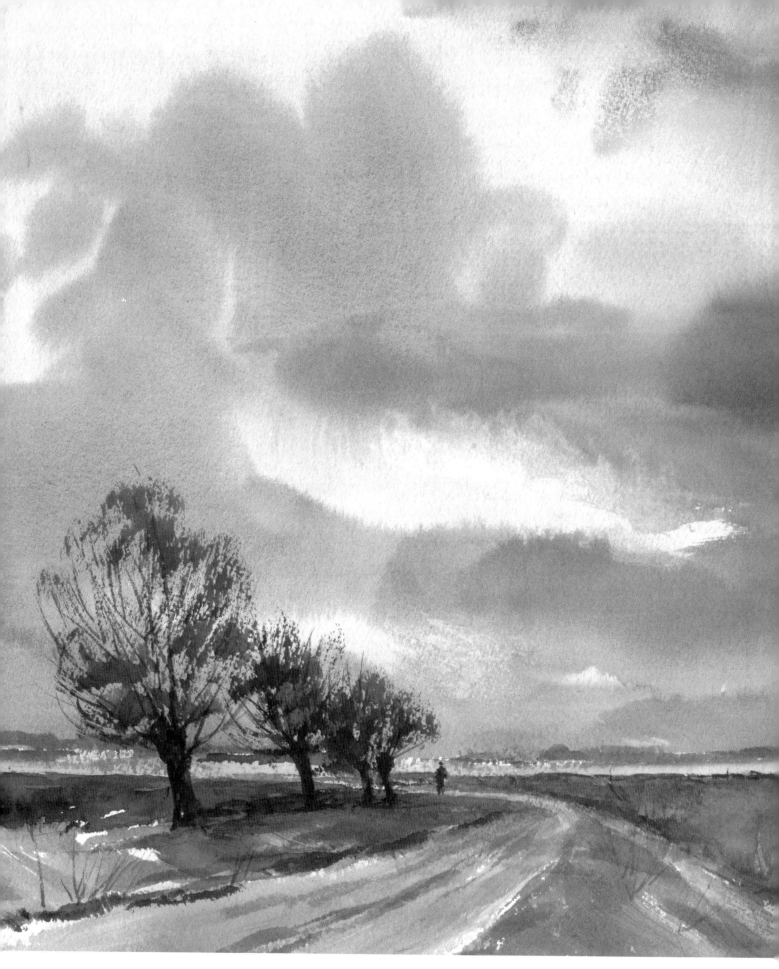

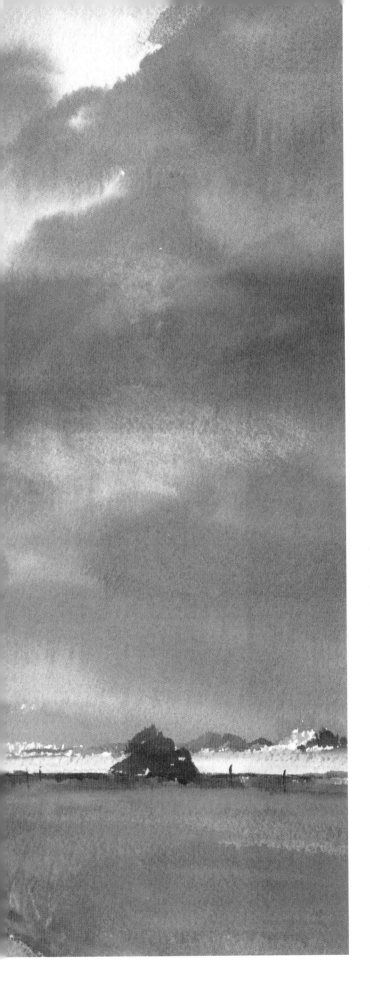

This type of sky is often known in the trade as a chaotic sky, which seems to me to be an excellent description. It's impossible to paint this sort of sky carefully. Instead, you just have to let yourself go, painting with abandon and with varying amounts of richness in your paint. One feature which attracted me to this scene was the way the cloud formations allowed the light to strike the land briefly but strongly. You can see this in the patch of light field on the right. It reminded me of the light Rowland Hilder used to love to get into his paintings and which he used to such great effect. I deliberately added the small dark bush to heighten the contrast. Notice how the row of dark trees on the left has been placed against the lightest part of the sky, and the way that the track leads the eye into the picture towards the figure. The trees also help to balance the dark cloud formation. You'll see that in some parts of the sky, the original weak raw sienna wash has been allowed to remain untouched. I had to work quickly, introducing thicker and thicker washes into the right-hand side of the sky, to build up the layers of cloud. The whole sky had to be completed in minutes, before the original wash had dried, while the landscape below could be produced in a less frantic fashion.

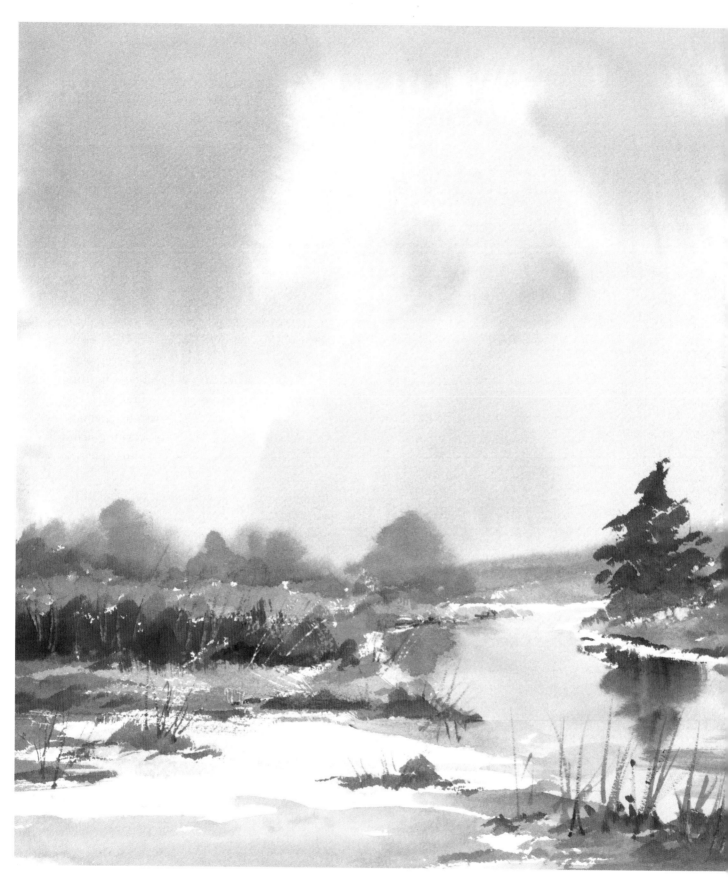

Completing the Picture

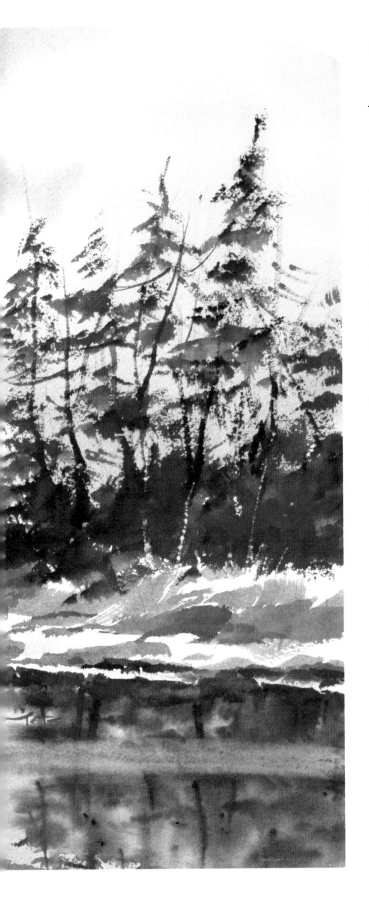

Although this is a book about skies and their importance in landscape painting, they can hardly ever be produced in isolation. You need a foreground, however minimal, to give them impact and scale. As we've said before, there should be a strong unifying link between the two, such as using common colours, vertical elements on the skyline, echoed shapes and in some cases cloud shadow on the ground or water. If you really want to enjoy your sky, then keep the foreground simple. You don't want the two elements fighting for pride of place. A busy foreground or street scene would be completely incongruous against a wild sky. Also, I must reiterate my warning about cutting the picture in half. The skyline must be above or below the centre of your paper.

Let's look now more specifically at some of the elements we've mentioned.

The skyline is, of course, where the land meets the sky, and as such is of vital importance to the success of your picture. Integration is the name of the game here. You must use every means available to avoid creating two separate units. Have a look at the illustrations throughout the book, paying particular attention to the various

The linking elements I've used in this picture are both soft and hard. The background trees and hills were put in while the sky was still damp; the large trees on the right were left until later. A point to remember is that leaving a gap in your painting for trees simply doesn't work, as the colour of the sky should always show through the branches. Note how the sky colour is reflected in both the snow and the river, providing additional unity. The reflection of the large trees in the water was put in wet into wet, providing further contrast with the hard trees above.

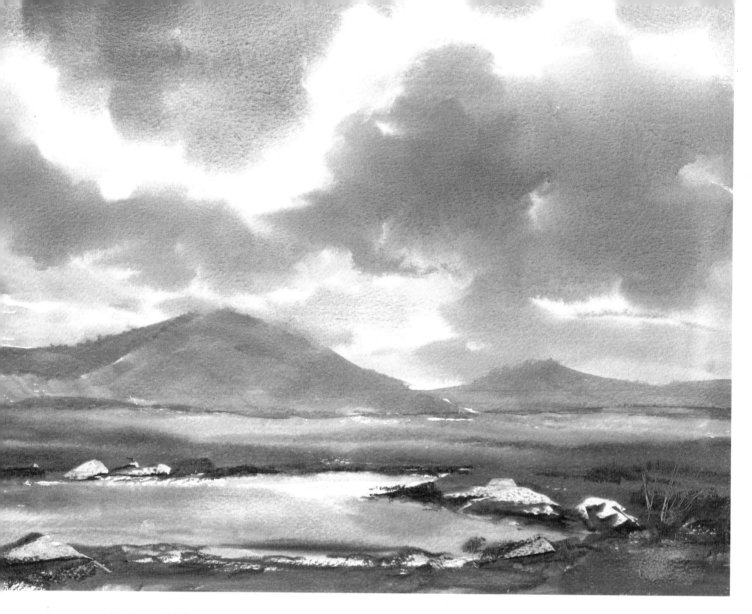

devices which I, and other artists, have used to integrate the two elements in a harmonious but exciting way.

These links can be either soft or hard. For example, in a Scottish highland scene, the foreground mountains might be painted up into the sky while the clouds are still wet, to give the impression of falling rain or mist. This would create a soft link and can be visually exciting, particularly if combined with some hard-edged mountains in the further distance – see page 117. Another example of this would be soft wet into wet trees, with a hard-edged tower on another part of the horizon. Remember, though, you always need to use strong paint on a still-damp surface to avoid too much fuzziness. Also, to obtain a really sharp, hard edge, you must wait until the sky is completely dry before putting

A good unifying feature is the sky colour being echoed in the foreground pond, while the link between land and sky is both hard and soft, as the low cloud drifts in front of the mountain. The hardness of the foreground rocks is a good contrast with the soft sky. This hard effect is achieved by the judicious scraping of a credit card on still-damp paint.

This peaceful and harmonious scene has been brought about by keeping all the colours to one side of the spectrum. The tree on the left is an important feature. It links land and sky, gives good contrast, balances the heavy cloud formation and introduces a richer note into the composition. Notice the placing of the birds in the lightest patch of sky.

in your tower. Nothing looks worse than fuzzy buildings caused by impatience.

Any sky painting will be predominantly horizontal and must therefore contain some minor vertical elements; otherwise you may end up with something that looks like a section of a sandwich! Here are some well-tried and trusted linking elements: towers or steeples; windmills; trees or mountains; cranes; telegraph poles; houses; the human figure; cliffs; docks; piers and jetties; sails – white against dark clouds are particularly useful. However, always remember to position these away from the centre of the painting. The magic formula for the ideal spot is a different distance from

each edge of the page. If you're using several objects try to interlock them to create one visual unit rather than a collection of scattered parts. The objects need to be counterchanged well for emphasis, no matter how small they are. For example, a sunlit church could be placed against a dark cloud. Conversely, a dark tower can be very dramatic against a light patch of sky. All these elements should be thought out while doing your tonal sketch. The sky will have to be designed to accommodate these effects. Remember too that you may have to reverse the dark/light effect half-way up. For example, a ship's mast may have to be light against a dark dock, but change

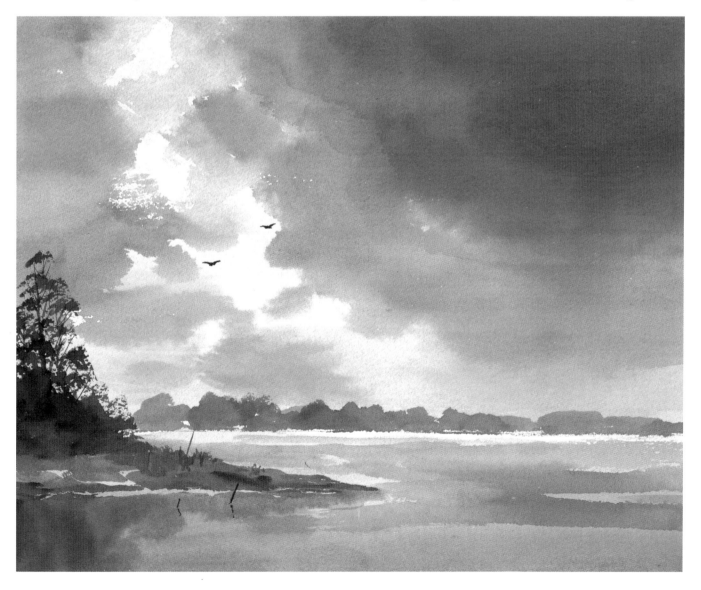

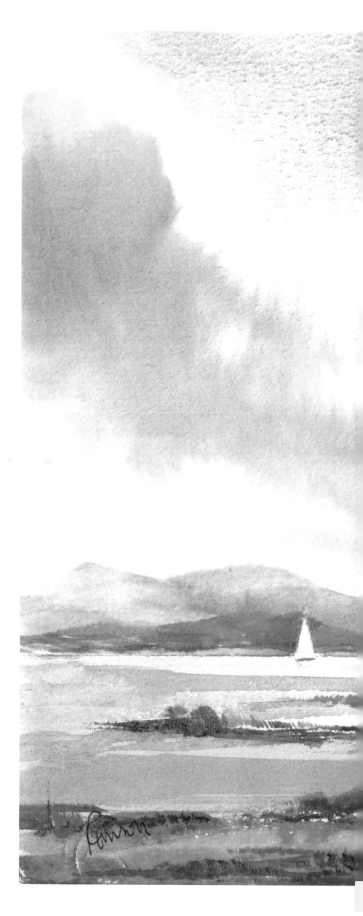

to dark where it reaches the sky. This may sound strange, but it does work visually.

I want us to look now at the general treatment of foreground. What we must avoid at all costs is linking a beautiful, liquid sky to a muddy and overworked foreground, thus ruining the whole picture. Often the problem is that although you have to put in your sky quickly to keep it fresh, unfortunately there is more time for the foreground, so you fiddle with it, putting in layer upon layer, ending up with mud. It may help to rehearse your foreground on a separate piece of paper.

Often with a sky picture, you'll have only about 4 centimetres ($1\frac{1}{2}$ inches) to convey a landscape going back perhaps 8 kilometres (5 miles). This is where you need to use your knowledge of aerial perspective to the utmost. The distant hill could be put in a flat grey blue, warming up gradually as you move towards the front of the picture, which will be in warm, rich colours, and it's in this area that you should confine any textural detail. Just have a look at the examples on pages 112 and 113. A favourite subject in foregrounds is rocks, and done well they can provide shape, contrast and even harmony. But they do need to be convincing, which means substantial! Rocks are heavy, hard and solid objects, so that is how they must appear in our paintings. If you have a good look at a rocky landscape, you'll see that the lightest part of any rock is always facing the light source, which is, of course, the sky. The sides are darker, and darkest of all is the part facing away from the light source. You can make good use of the shadows cast by other objects to show up the shape of the rock, while if you keep the base

Here the yachts of varying size introduce a contrasting vertical element into a mainly horizontal painting, as well as giving a focal point. A difficulty with this type of foreground is establishing a strong textural quality without overworking. One technique is to leave areas of white paper which gives sparkle. However, don't overdo it – you don't want to end up with scattered whites!

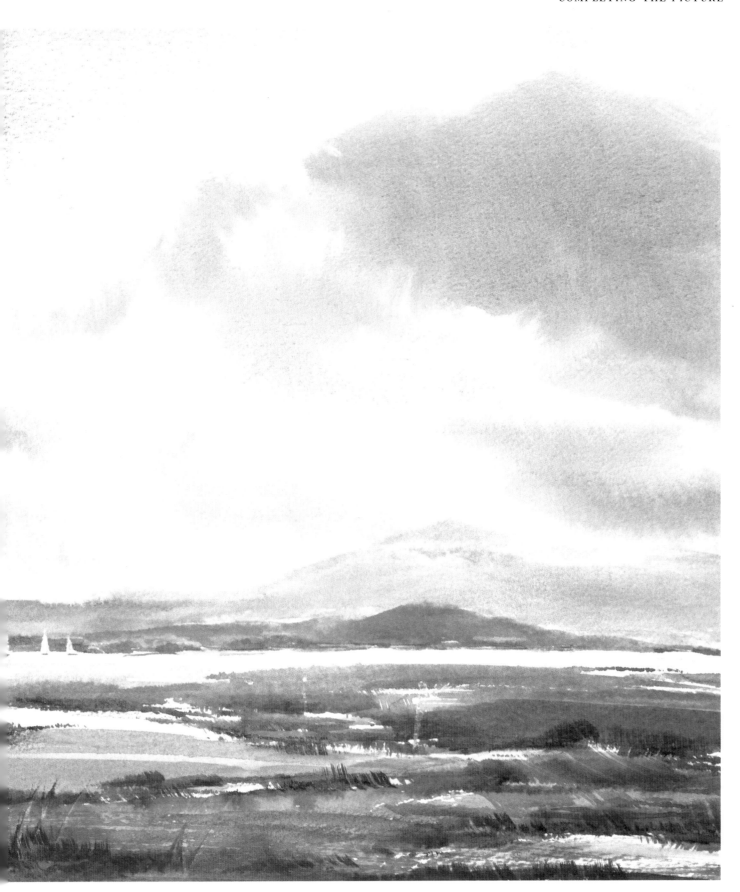

lighter in tone, it gives the impression of light bouncing off the ground.

You will need texture on the rock. One way to establish the top surface is with the swift stroke of a dry brush. Another is to remove paint from the top surface with a credit card while the paint is still damp. Directional strokes are valuable here too, horizontal for the top and vertical for the side. As always, make good use of counterchange. Show up the profile of a dark rock against a light background, or vice versa. Vary the size of your rocks, and the distance between them, to prevent boredom. Making them larger in the front and smaller in the distance will help the perspective. Have a good variety of colour too. I like to use different amounts of brown and blue mixed together. Any buildings in the foreground need to be left simple. A whole wall should be painted

as a mass of varying colour, with just a little surface texture. Employ counterchange again to bring excitement into your foreground. If you're using fields or woodlands, remember to confine texture to the very front of your picture.

An important part of the foreground will be the device used to take the eye into the picture. There are many ways of doing this. It could be a lane or a stream, or the curve of a beach, but they must all create interest, inviting the viewer into the painting and up to your focal point.

The trees here are a very important part of the composition, enhancing the gentler sky. Their calligraphy also provides a useful link, giving unity to the picture. The elements of unity and harmony are strengthened by the reflected colours in the lake, while contrast is provided by the rich tones of the trees against the much cooler sky.

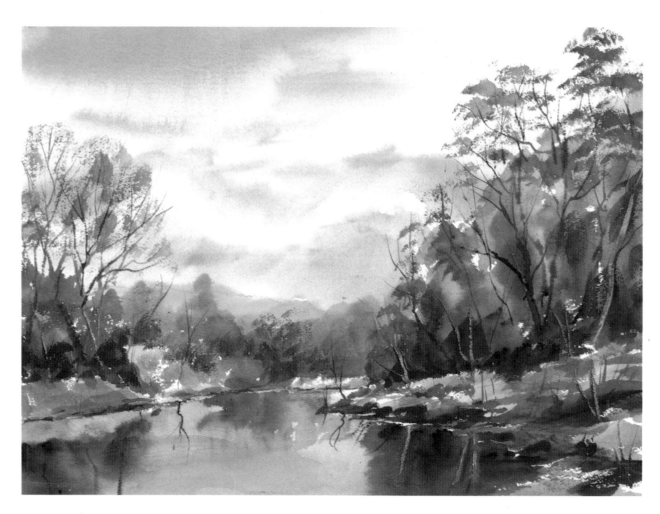

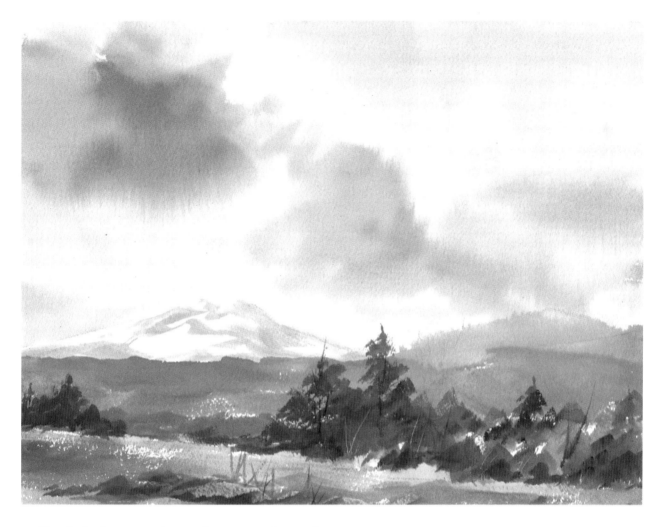

Cloud shadows can be used to great dramatic effect on a distant hillside, but remember to diminish their size as they recede. They may be racing across the landscape or forming deeper tones on fields or buildings, or changing colours on a sea or lake. One method of unifying the foreground with the sky is to repeat some of the sky colour. Water will always reflect back the colours in the sky and can be very effective, but this repetition need not apply only to water. The colour of some clouds can be repeated in distant woodland, while a white fluffy cloud may be echoed in a white building. Also, the shape of a cloud can be echoed by similarly shaped trees on the ground. Once you have learned to look at the scene in front of you, the possibilities are endless.

As well as inland landscapes, you will find that seascapes, beaches and estuaries make exciting foils to a sky painting. They provide excellent opportunities for cloud shadows on the water.

This is another painting where the trees have a variety of tasks to perform in the composition. Their weight and colour balance the dark cloud in the left of the sky, while they also contrast well with the cool serenity of the snow-covered mountain. This cool quality is enhanced by the blue greens in front of the mountain, and the picture gradually warms up as we reach the foreground – an aid to perspective, as well as a good lead into the picture.

A foreground wave will make a good link between sky and sea. In a beach scene, when indicating pebbles, it's often sufficient to put in a flat but colourful wash using a dry brush technique. Just a suggestion of pebbles in one corner will stimulate the viewer's imagination. Similarly, grasses on sand dunes should be done economically; putting in each blade will simply look monotonous.

Examples from the Experts

Over the years, through my work as an artist, and perhaps even more as an author, I have met and established friendships with many artists around the world. *Watercolour Impressionists* and *Modern Oil Impressionists* were two books which widened my circle of artist friends immeasurably. I thought it would be fitting, therefore, to end this book with the work of three friends whose skies I particularly admire. All three regard skies as a very important part of their painting, and I'm sure you'll agree that this is apparent in these last few pages. It's also good to be able to show skies in different media.

Trevor Chamberlain is equally accomplished in oil and watercolour and his work was represented in both of the books mentioned above. He and I also cooperated on two instructional books in oils. Trevor is a true Impressionist, preferring to work outside in all weather to capture that freshness which was so important to the great French Impressionists. His style is based on sound technique, but this is never intrusive. There is a quality of light in his paintings which I have long admired. Trevor is a very private man whose life is centred around his painting and he is simply not interested in teaching or making videos, whereas

This oil painting of an evening scene at Burnham Overy Staithe is so evocative of Norfolk rivers. I know them well, having sailed on them over many years. Although Ian has used a very restricted palette, he seems to have captured even the smell and the taste of the scene. The whole landscape is flooded with light from the evening sky which adds to the strong feeling of unity in this atmospheric painting.

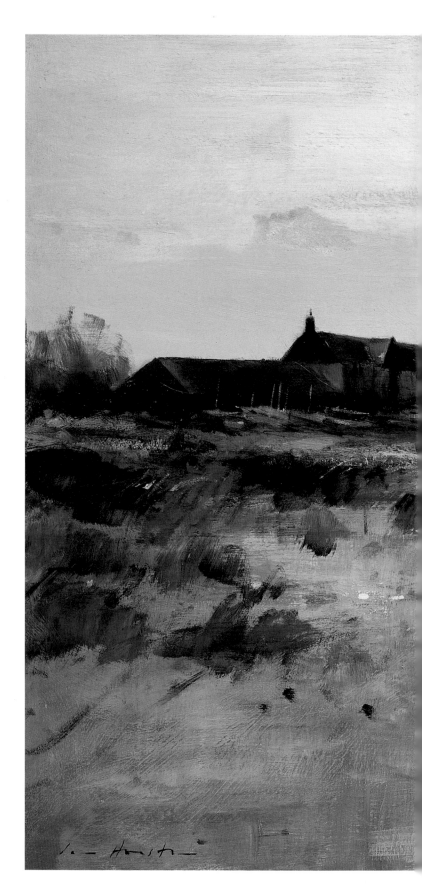

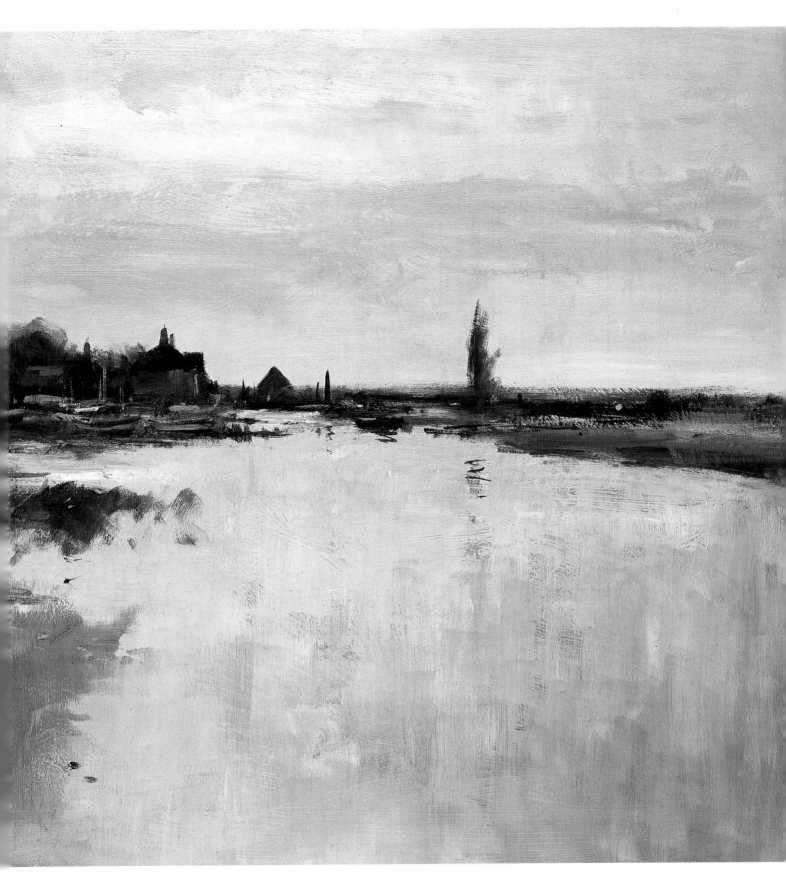

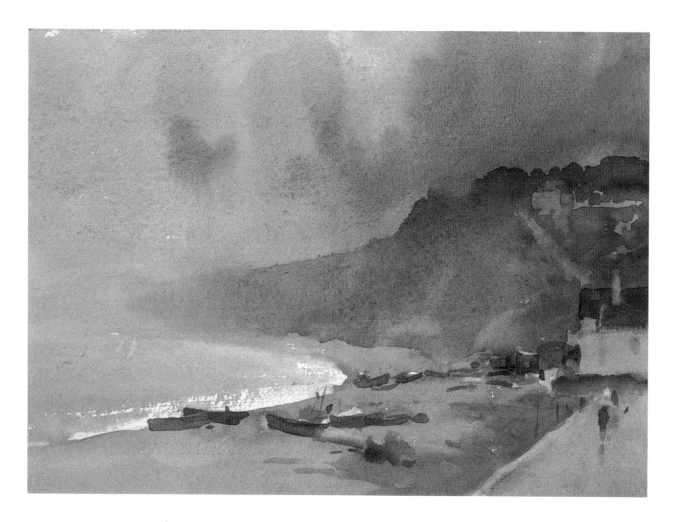

This is a favourite scene of Trevor's which he has painted in many different weather conditions. Each one, however, is completely changed as he captures the atmosphere of the scene with his masterly rendering of the skies which produce the weather. Here, in his watercolour *Rain at Budleigh Salterton*, we see an almost deserted beach as the rain sweeps in from the sea, and the hardy couple on the promenade seek shelter under their umbrellas. I particularly like the way the coastline disappears into the rain.

Cumulus clouds race across the sky (above, right), casting their shadows on the countryside below. Barry's knowledge of cloud formations is indicated by the authenticity of his skies. You're never left with just a vague hint of sky. One cloud dominates, adding both strength and recession to the scene. The landscape, painted in pastel, is enlivened by the light and shade as the clouds are driven by the wind.

Barry Watkin enjoys all three. Teaching is an important part of Barry's life, and he has thoroughly enjoyed his incursion into video making. His passion, though, is for pastels and his use of this medium is masterly. Barry is one of life's gentlemen, always courteous and a joy to have dealings with. My third guest painter is Ian

This dramatic evening sky, also by Barry, completely dominates the city, with its cathedral and churches. The buildings, though, have their own part to play as they link earth to sky, providing unity, and contrast sharply with the soft sky. The sky is full of cool and warm colour to an extent which almost takes one's breath away.

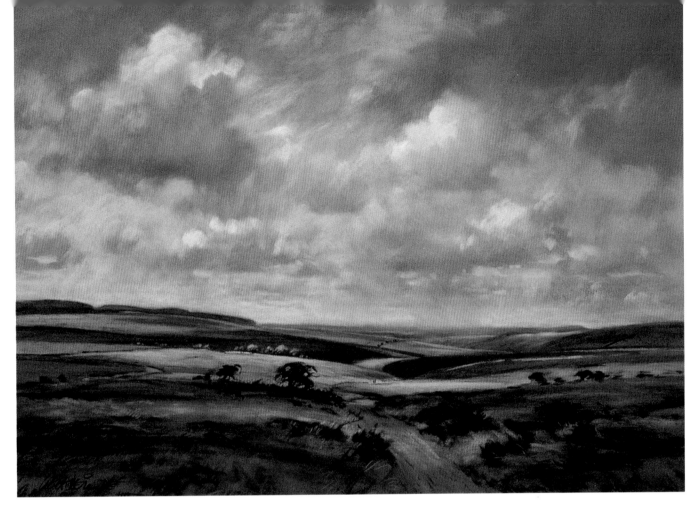

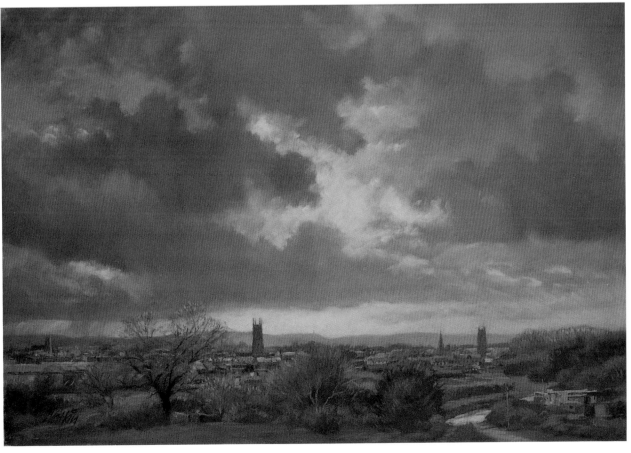

Houston, an oil painter who carries on the wonderful tradition of Edward Seago. I have often had moments of envy when thinking of the opportunities Ian had of talking, sailing and painting with Seago, whose work has always been such an inspiration to me. Ian paints mainly in oils in a bold, free style, capturing his subject in a way that projects the atmosphere of the scene. Even the most complex of his skies are done with

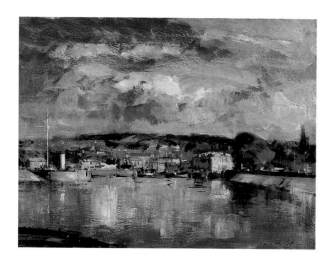

Barry has chosen a vertical format for this exciting skyscape (right). He's created a tremendous sense of space and distance by his use of the billowing cloud formations. You'll notice how there are three well-defined layers, each decreasing in size as it recedes towards the horizon. The echoes in the landscape below also help to give depth and aerial perspective, as the reflected colours in the water give a feeling of harmony to the composition.

Ian seems to get so much weight and solidity into his clouds with very few strokes, relying on the contrast and strength he gets into his brushwork. The scene, *Sunlight after Rain, Honfleur* (left), is unified by the echoes of sky colour in the water and buildings below.

In this again deceptively simple watercolour of Mounts Bay in Cornwall, Trevor has made the utmost use of aerial perspective, dividing the scene into three distinct layers of depth. He's used a very restricted palette, which has helped to harmonize the whole painting. The rain clouds have been beautifully portrayed, without being obtrusive. Trevor really is a master of understatement.

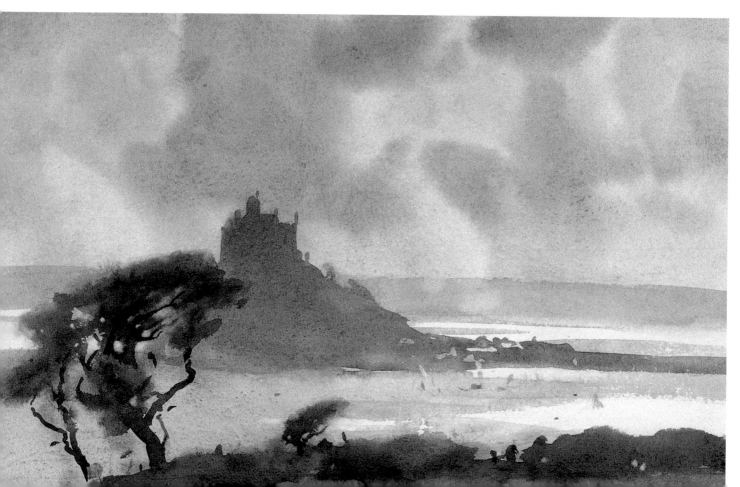

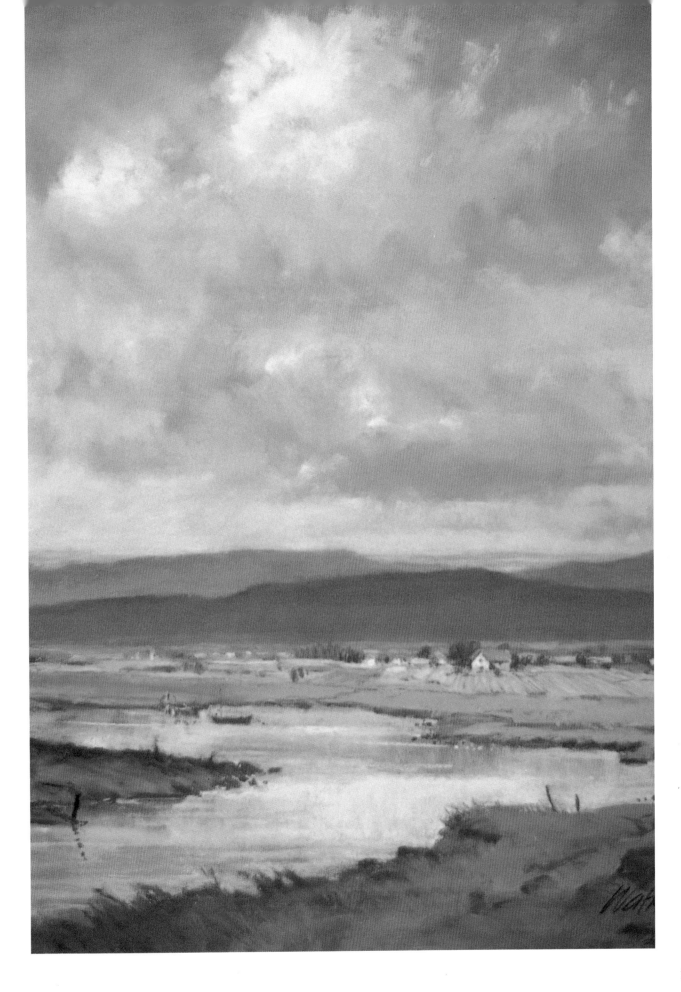

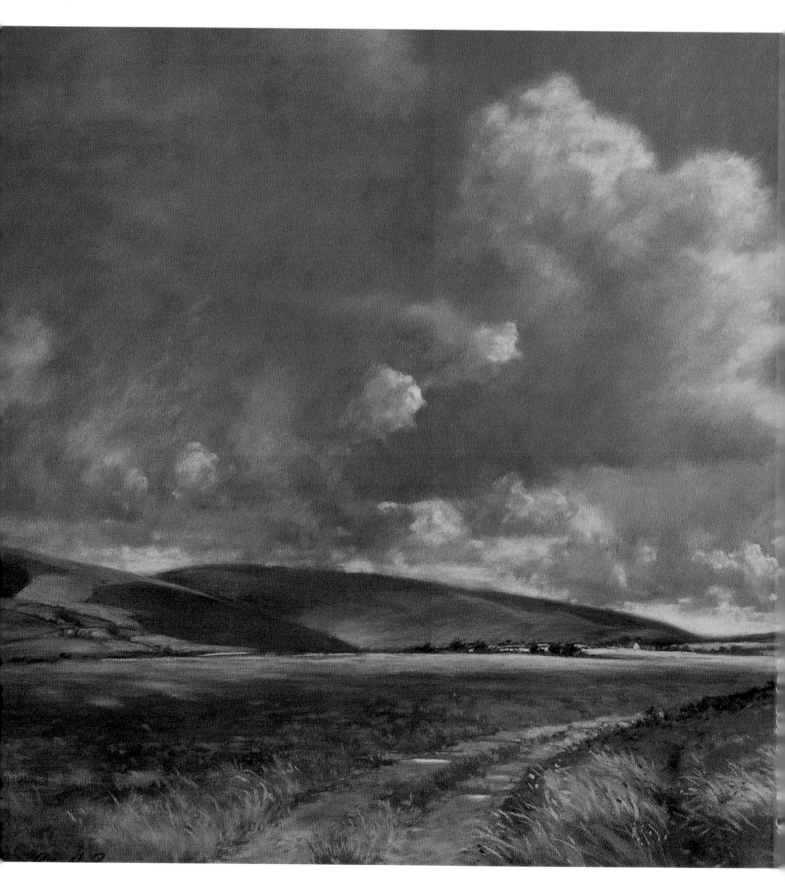

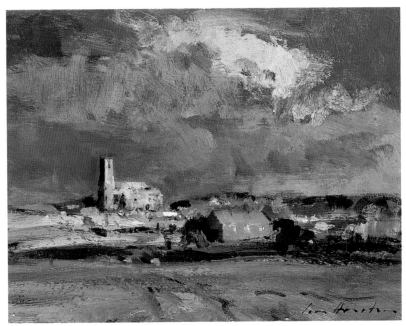

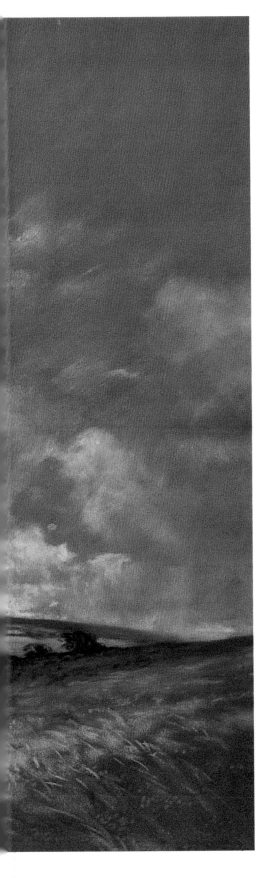

Ian, in his *Sunlight after Rain, Norfolk* (above), has used a device which has been popular with many other famous artists: a well-lit building against a stormy sky. He has used it to great effect, creating drama and excitement. These dramatic conditions are often so fleeting, they are over within seconds. Notice how the sunlit building is counterbalanced by the light cloud. All in all, this is a very satisfying and stimulating composition.

Barry has pulled out all the stops here in painting this incredibly strong skyscape. He's used one dominant cloud, the rest being in enhancing and supporting roles. There is vigorous left to right movement here, which is emphasized by the direction of the foreground path. Again we have the dappled sunshine, which is so effective and which Barry has used to lend depth and excitement to his portrayal of this moorland scene.

enormous economy of stroke, but this is soundly based on knowledge and experience. I admire his work enormously and was delighted when he agreed to show his paintings in the book *Oil Painting Impressionists* and again in this final chapter of *Skies*.

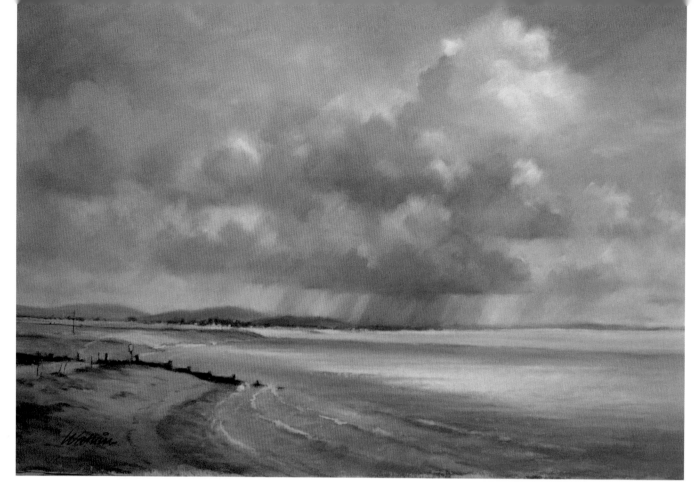

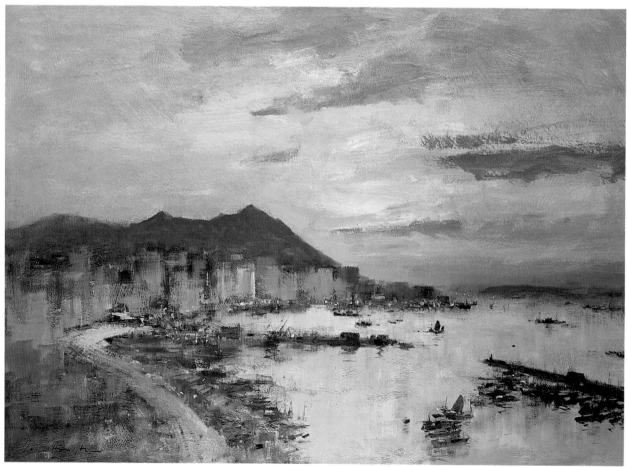

126

There is some really serious weather approaching here, with distant rain already descending from the cumulonimbus clouds. The clouds have been built up in distinctive altitudinal layers. The cloud shadows add to the atmosphere of apprehension as the storm comes ever nearer. Although the colour scheme is basically cool, the scene by Barry is enlivened by the clever use of minor touches of warmth.

Ian's *Hong Kong at Sunset* (opposite, below) is a complex view of city and harbour, complete with skyscapes and hundreds of boats, and has been depicted with masterly simplicity. There's a lovely range of colours in the evening sky, which is repeated in the sea below. The sky is the star of this scene, supported by the restrained use of colour throughout the rest of the painting.

The sky again dominates in this lovely watercolour, *After a Shower, Putney.* Balance is provided by the tree on the left and the dark area of cloud on the right. Notice how Trevor has used counterchange to the utmost, putting all the activity of figures and boats against the lightest part of the picture, so that the eye is directed immediately to this area of interest.

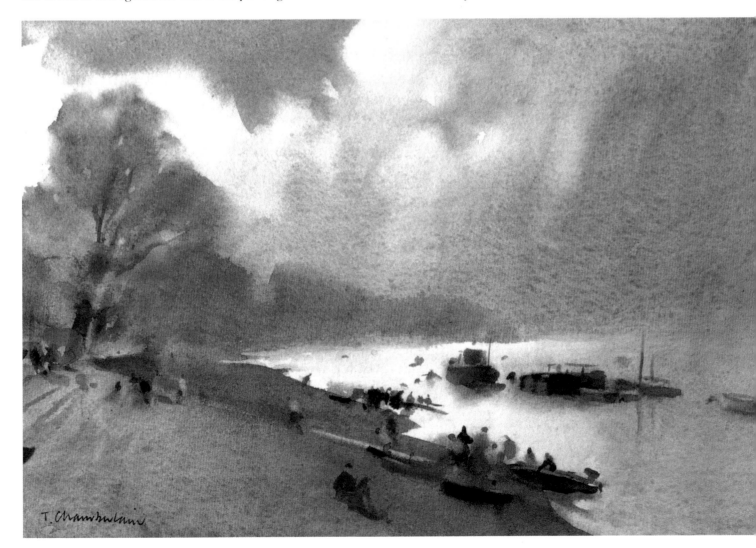

Index